MAFIA COP KILLERS

in

AKRON

MAFIA
COP KILLERS
in
AKRON

THE GANG WAR BEFORE PROHIBITION

Mark J. Price

THE
History
PRESS

Published by The History Press
Charleston, SC
www.historypress.net

Copyright © 2017 by Mark J. Price
All rights reserved

First published 2017

ISBN 9781540227393

Library of Congress Control Number: 2017948519

Dedicated to Guy, Edward, Joseph, Gethin and George.

CONTENTS

ACKNOWLEDGEMENTS

My name is on the cover, but I didn't do this alone. Many, many people helped in the creation of this book in ways both large and small. When the research felt overwhelming and the writing seemed insurmountable, I marched forward with the assistance and encouragement of others. I will forever be grateful for the expertise and guidance I received from close friends and total strangers. Thank you to all!

First, I must acknowledge the tireless work of Akron–Summit County Public Library's Special Collections Division. Recently retired manager Judy James; her successor, Mary Plazo; and librarians Iris Bolar, Cheri Goldner, Jane Gramlich, Rebecca Larson-Troyer, Barb Leden and alumnus Michael Elliott are a friendly team of history detectives who are unparalleled at digging into the past and gathering facts. No matter how many inane, trivial questions I posed, they always provided service with a smile.

Similarly, the intelligent, genial staff at the University of Akron's Archival Services—Head Archivist S. Victor Fleischer, John Ball, Mark Bloom and the late, great Craig Holbert—and Cleveland Public Library assistants April Lancaster and Doug Westerbeke rescued me again and again. I appreciate their kindness.

In the search for public records from a century ago, I received invaluable aid from Sandra Kurt, Summit County clerk of courts; Scott Feeney, chief of staff for the clerk of courts; Daniel Brand, office manager for the clerk of courts; Gary Guenther, chief investigator for the Summit County Medical Examiner's Office; and Kognia Woodall, deputy clerk at Summit County

Probate Court. Likewise, Lily Birkhimer, digital projects coordinator at the Ohio History Connection, helped me track down some amazing photographs of Ohio Penitentiary convicts from a century ago.

In the quest for understanding, I benefited greatly from the shared wisdom of Detective James Conley, Sergeant Tom Dye, Officer Robert Patrick, Officer Jeff Ross, Lieutenant Jim Buie and the late Captain John T. Cunningham. I truly appreciate the counsel of local historians David Lieberth, Leianne Neff Heppner and Dr. George W. Knepper. They are a blessing to the community.

I'm extremely fortunate to have a trusted network of relatives and friends who never cease to provide a wealth of inspiration and knowledge: Al and Bootsie Bollas, Jon and Maria Bollas, Nick and Lindsey Bollas, Joe and Kelley Cali, David de la Fuente, Joe Del Medico, Mark and Diane Ferenchik, Jeff Gallatin, Tony Gapinski, Debby Stock Kiefer, Joe Kiefer, Steve Neff, Nick Owens, Rosie and Gene Owens, Sean Owens, Tim and Sharon Ricks and Glenn Stephenson.

Special thanks to Drina Beeman, Dave Bersnak, Reverend Bob Denton, Fred Endres, Craig Erskine, Kathy Fraze, Bernie Gnap, Steve Hammond, Joe Harper, Phyllis Heischuber, Robert Herceg, Bruce Larrick, Pat Marks, John Miller, Kevin Murphy, Guerrino Rich, Dan Rinaldo, Jim Skeese, Mary Jane Stone, Ron Syroid, David Weyrick, Larry Zvara and Jim Zwisler.

I am forever indebted to Bob DeMay, photo editor at the *Akron Beacon Journal*, for sorting and scanning most of the images that you see in this book, and to Kim Barth, director of photography at the *Beacon Journal*, for granting permission to publish many rare pictures from the newspaper archives. I am also in awe of chief librarian Norma Hill, who has a knack for finding articles and photos when I'm just about to give up. And to all my hardworking colleagues on the copy desk, I say, "Is it deadline yet?"

I'd definitely like to thank Krista Slavicek, former acquisitions editor at The History Press, who approached me about writing another local history book after the success of *Lost Akron*, and Candice Lawrence, acquisitions editor, who enthusiastically took over the project. I'd also like to thank Ryan Finn, The History Press copy editor who combed these pages for typos and grammar—and who quickly discovered my admittedly limited knowledge of the Chicago Manual of Style—as well as Victoria Boneberg, the marketing specialist who provided assistance with sales and outreach.

Where would I be today without my parents? My late father, Joel Edwin Price, was a gifted writer and poet, and I know he'd be thrilled to see his comic book–loving son earn a respectable living as a professional journalist

and author. My wonderful mother, Angela Bollas Price, the first member of our family to edit a newspaper, remains a faithful supporter, a trusted adviser and a whiz at 1950s music trivia. She taught me how to read and write and how to tell right from wrong. Thanks, Mom! I love you.

Finally, I want to thank my beautiful, cheerful, helpful and thoughtful wife, Susan Gapinski Price, an award-winning editor, talented writer and incredible person. She is my soul mate, best friend, copy editor, dining partner, movie co-viewer, concertgoer, vacation planner, puppy walker, package opener and personal tech. She saves me every day—and I can't thank her enough for making my life a joy. I love you so much, Susie! As Aerosmith and I sang on our wedding day: "Every moment spent with you is a moment I treasure. I don't want to close my eyes. I don't want to fall asleep. 'Cause I'd miss you, babe. And I don't want to miss a thing."

INTRODUCTION

H ow did I not know the story? I've lived in the Akron-Canton area for most of my life, the fourth generation on both sides of my family to reside in Summit County. Countless tales were handed down to me, but not this one. Maybe my great-grandparents didn't want to remember it.

For nearly twenty years, I have written "This Place, This Time," a weekly column about local history in the *Akron Beacon Journal*. During the column's formative years, I stumbled across a reference to the Furnace Street gang and its deadly war against Akron police in the early twentieth century. It was one of the most shocking chapters in the city's esteemed and occasionally lurid history, and I had never even heard of it.

Each day, thousands of vehicles zoom past the eternal flame at the Akron Police Memorial in front of the Harold K. Stubbs Justice Center on South High Street in downtown Akron. I've glanced at it hundreds of times—perhaps more—because the monument is only a few blocks north of my office. I didn't know that so many of the etched names on the marble slab belonged to men who were killed in a fifteen-month span.

Black-and-white pages blurred together when I sat at the Akron library's microfilm machine to examine vintage newspaper articles about the infamous series of crimes. The low hum of the machine served as white noise as I read the stories in rapt attention, occasionally taking notes on a legal pad or printing out copies. After months of dimly lit editions flashed past my retinas, I grudgingly pushed the rewind button and returned the microfilm boxes back to their shelf.

I couldn't possibly write a history column about this! The plot was too complex and the subject too important to be condensed into a single article for "This Place, This Time." So, I gathered my notes, placed them in a box and hid them away for another time. Before I knew it, a decade had passed.

A mental calendar began flipping its pages. A few years ago, I realized that December 2017 would mark the 100th anniversary of the Furnace Street gang's reign of terror. When The History Press approached me about writing a follow-up to my 2015 book *Lost Akron*, it dawned on me what the topic should be. I couldn't be the only native son who didn't know about the 1917–19 gangland war. I dusted off the old notes and began new research, compelled to tell the story to a new generation.

Sadly, this true-crime tale is timelier than ever. With more than sixty officers killed in the line of duty last year in the United States and hundreds of police-related shootings stirring protest and controversy, it's impossible to regard the tragic events of one hundred years ago as merely a peculiarity from yesteryear.

A century isn't nearly as long as it seems. When I thumbed through vintage Akron city directories to see who lived and worked on Furnace Street during that tumultuous era, a dozen familiar surnames jumped off the pages. I attended Akron's North High School in the late 1970s and early 1980s with students who shared those last names. These were good kids from good families. Did their ancestors claw their way out of that tough environment to find a better life? As the great-grandson of a bootlegger and reputed mobster, I know how much can change over a few generations. My cousin is a police detective.

Although I moved away from North Hill years ago, it still feels like home to me. The Akron neighborhood, which rises up from North Howard Street like some modern-day Camelot, stands directly across the Little Cuyahoga Valley from Furnace Street. For generations, it was nicknamed "Little Italy," a tribute to the immigrants who lived there.

Life was a green, white and red tapestry of Italian restaurants, specialty markets, businesses, social halls, private clubs, spaghetti dinners, bake sales and solemn rites at St. Anthony of Padua Catholic Church. Fortunately for Akron, vestiges remain from that golden age, including DeVitis Italian Market, Dontino's Fine Italian Cuisine, Unione Abruzzese, the Italian Center, Emidio's Pizza, Carovillese Lodge & Club, Crest Bakery and Rasicci's Pizza.

That is the community that I grew up loving. That is the community that the Furnace Street gang could not destroy.

THE CITY OF OPPORTUNITY

T he first thing that visitors noticed about Akron was the smell. A thick, pungent cloud of sulfur hung low over the Ohio city, an acrid fog that made nostrils flare and eyes sting. It was a gray, grimy town with billowing smoke, drifting soot and lingering haze. Yet people couldn't wait to go there.

In the early twentieth century, Akron was a boomtown where jobs were plentiful, opportunities were bountiful and fortunes were attainable. Newcomers arrived every day to claim their stake.

Thanks to the surging popularity of automobiles, Akron tire makers Firestone, General, Goodrich, Goodyear, Miller and dozens of other rubber companies were noisy, bustling operations that operated twenty-four hours a day but still couldn't meet demand. They needed to expand factories, boost capacity and add products, and to get it all done, they needed to hire more workers—and quickly.

Akron companies took out classified ads in newspapers across the nation, practically begging for help:

> *Wanted at once: 100 intelligent and able-bodied men. Apply to the B.F. Goodrich Co., Akron, Ohio.*

> *Wanted: Good strong, reliable men for factory work. Steady employment, good wages. Write or apply to Employment Office, Firestone Tire & Rubber Co., Akron, Ohio.*

Newcomers to the "City of Opportunity" pose for a souvenir portrait in the early 1900s at Arcade Studio on South Howard Street. The backdrop resembles the Akron Limited train. *Author's collection.*

Wanted: Unskilled men for production work. Ages 18 to 45. Weight 140 pounds or more in good physical condition. Good living wage paid while learning. Steady work assured. Apply in person or communicate with Factory Employment Office, the Goodyear Tire & Rubber Co., Akron, Ohio.

Out-of-state laborers and foreign immigrants flocked to Akron, quickly landed factory jobs and wrote home to notify their friends and relatives that the Rubber City was still hiring. The Akron Chamber of Commerce proudly hailed the community as the "City of Opportunity," a promotional slogan that was plastered on a giant billboard that welcomed railroad passengers at Union Depot.

Founded in 1825 as a village on the Ohio & Erie Canal, Akron was not quite a century old. Its early industries included clay products, farming equipment and breakfast cereal before Dr. Benjamin Franklin Goodrich of New York moved to Akron in about 1870 to open the first rubber company west of the Alleghenies. No one in the village of ten thousand could predict that pliable rubber would cement the future. When F.A. Seiberling and his brother C.W. Seiberling co-founded Goodyear in 1898 and Harvey Firestone established Firestone in 1900, Akron's reputation as the "Rubber Capital of the World" was secure.

The sulfur-infused stench of smoking factories was hailed as "the smell of jobs." In less than a decade, the old canal town had transformed into a major industrial city. Its rubber factories expanded from 22,000 workers in 1910 to more than 70,000 in 1920. At the same time, Akron's population swelled from a svelte 69,067 to a stout 208,435, making it the fastest-growing city in the United States.

Frankly, there was no place to put all those people. Contractors slapped together houses as quickly as possible. Families rented out basements to strangers. Shanties sprouted on the outskirts of Akron. Rooming houses offered beds in shifts, forcing three rubber workers to take eight-hour turns.

Workers skipped town if they couldn't find decent places to live. Goodyear and Firestone aimed to resolve the problem by building affordable homes for workers and their families in the new residential developments of Goodyear Heights (1913) and Firestone Park (1916).

Longtime residents were pleased to see their city's prosperity in the early twentieth century, but many were alarmed by the rampant growth, which put a strain on housing, sanitation, utilities and infrastructure. As Akron historian Karl H. Grismer (1896–1952) noted, the seismic change was not entirely welcome:

Akron's flag flies proudly in this Arcade Studio portrait from 1912. The city's population grew from 69,067 in 1910 to 208,435 in 1920 as laborers sought jobs at rubber factories. *Author's collection.*

Most displeasing of all were the crowds which now surged madly through the city. Never before had Akron seen so many people. Like a rampaging colony of ants, they filled the streets and sidewalks and choked the streetcars, theatres and restaurants—even in churches. Everywhere there were crowds—pushing, milling crowds, often fighting crowds. Almost every day, it seemed, the crowds became larger.

As strangers flooded the city, Akronites were bewildered to hear a cacophony of foreign languages and unfamiliar accents, perhaps forgetting that it was only a few decades earlier when nearly one-third of the city's population spoke fluent German. The town was not immune to xenophobia, and foreigners were often viewed with distrust and disrespect. By 1915, as the Great War raged in Europe, Akron was home to an estimated 4,500 Serbians, 4,000 Hungarians, 3,500 Italians, 3,000 Romanians, 2,000 Slovaks, 1,500 Austrians, 200 Armenians and thousands more from miscellaneous ethnicities—truly a melting pot.

The Akron YMCA held Americanization classes at night to help the newcomers assimilate but found it challenging to weld such disparate groups into one nationality. Many did not speak English or understand local customs. Urging Americans to try to better understand foreigners, immigration expert Edward A. Steiner, a professor at Grinnell College in Iowa, praised the YMCA's efforts in a 1916 lecture at the First Methodist Church in Akron:

> We get the pick of the men from foreign lands. They must pass physical examinations before they can buy a ticket. At Ellis Island, they must undergo still more stringent tests, more searching than we would have to face for life insurance. The men are fine specimens. They come to us abounding in health and youth and vitality and energy. How do we treat them? We give them the hardest, the most dangerous, the dirtiest work to do. They see the saloon and the poolroom, the women of the street, the unscrupulous employment agencies. They often miss the real America.

There was no test for malevolent intentions, though. Besides attracting hardworking laborers, Akron also was the "City of Opportunity" for criminals, connivers and crooked characters. Young factory workers, new to town, had money to spend—and there was no shortage of ways to spend it. Gambling parlors, billiard halls, unlicensed saloons and houses of ill fame lurked in shady corners of town.

Criminal arrests nearly doubled in Akron from roughly 5,900 in 1915 to about 10,600 in 1916. Safety Director Charles R. Morgan urged the public to help the police department as much as possible, saying the seventy officers on the force were woefully overworked, and it was the civic duty of all citizens to look out for robbers, thieves, burglars, pickpockets and other riffraff. "I wish every resident of Akron would look upon himself as a special officer and report any unlawful acts which come to his attention," Morgan

said. "It isn't necessary for a man to be a regular policeman or even a deputy in order to report misdemeanors and assist in bringing criminals to justice." Only then would the crime wave ebb, Morgan maintained.

Detective Harry Welch, a police veteran of twenty years, was convinced that Akron's fine, upstanding residents weren't suddenly turning criminal. More than likely, it was the newcomers who were responsible for most of the recent problems, he said. "I have watched the town grow, and have studied its criminal element," he said. "Akron entertains more degenerate transients than any other city in northern Ohio, not excepting Cleveland. It's the town that's growing, not the criminal element."

Welch was convinced of one other thing: It wasn't a crime wave. "It's here to stay," he said. "Just as it is in every large city."

Mayor William J. Laub issued a proclamation on April 3, 1917, that no foreign-born resident "need fear any invasion of his personal or property rights as long as he goes peaceably about his business and conducts himself in a law-abiding manner." He concluded, "I urgently request that all our people refrain from public discussion which might arouse personal feeling, and that they maintain a calm and peaceful attitude toward everyone, without regard to their nationality. A very large group of responsible Akron citizens have pledged me their support in maintaining law and order and in guaranteeing to all foreign-born citizens their full rights under our government."

Three days later, the United States entered World War I. As nearly nine thousand Akron men marched off to battle, women and foreign-born laborers picked up the slack in local factories. Rubber companies welcomed the arrival of so-called aliens as long as they were willing to work hard and follow company rules.

Akron war plants kicked into overdrive, producing military tires, gas masks, boots, gloves, balloons, blimps, hoses, hospital supplies and other rubber products for the Allied effort. New Jersey journalist Edward Mott Woolley (1867–1947) marveled at the boomtown chaos in a July 1917 *McClure's Magazine* article titled "Akron: Standing Room Only!"

> *In Akron there is no quitting time at the rubber factories except at twelve o'clock Saturday night, but every eight hours these vast establishments turn themselves inside out. I stood one afternoon and watched the first shift come out at a plant that employs twenty-one thousand people, and when the flood broke, it was a tidal wave of humanity. It swamped that part of Akron. From sidewalk to sidewalk it rolled down the street, and up it, and swept through every channel and rivulet. Things are doing in Akron. There is*

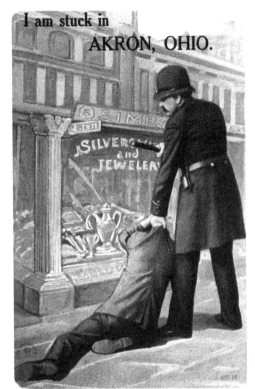

Right: Don't get stuck! A plant worker mailed this comical, police-related postcard from Akron to a cousin in West Virginia in 1913. "You ought to come out and git you a job," he wrote. "There are lots of work." *Author's collection.*

Below: Patrolman Frank McAllister walks the beat on North Howard Street in about 1900, with North Hill looming behind him. *Courtesy of Summit County Historical Society.*

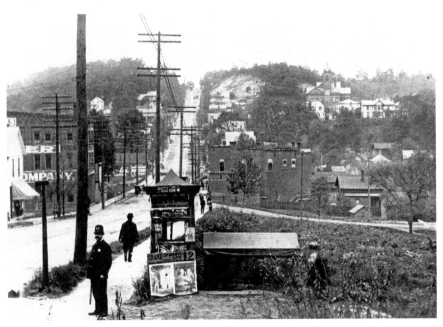

standing room only. This is scarcely a jest. There are thousands of beds that are working in shifts like factories. The man who oversleeps is dragged from under the covers by the roomer who has the next ticket.

Dr. Charles T. Nesbitt, who took over as Akron health commissioner in December 1917, cautioned that darker days were ahead. "When great prosperity comes to a city followed by a great influx of population, there nearly always follows a wave of crime and disease," Nesbitt explained. "The moving of people increases the personal contact, and prosperity always makes a city more attractive to criminals. There is more profit in crime and less chance of detection."

Akron lost more than three hundred troops in World War I, but the death toll at home was even greater. The arrival of Spanish influenza sickened more than five thousand Akron residents, killing at least six hundred people and turning hospital wards into morgues. Another three hundred died of pneumonia.

Amid the chaos, the criminal element kicked into overdrive. Distracted by war and disease, the gray, grimy city was vulnerable to attack from within. Nothing could prepare Akron for the horrors to come. The melting pot was bubbling over. Stretched to the limit, the Rubber City was about to snap.

NIGHT WATCH

Rage and anarchy filled the streets of downtown Akron during the riot of August 21, 1900, the darkest night in the city's history. A lynch mob demanded that police turn over Louis Peck, a thirty-six-year-old black man accused of criminally assaulting a six-year-old white girl, Christina Maas.

An angry crowd grew from a few hundred people to five thousand outside the Akron City Building, where the mayor, council and other municipal leaders kept their offices and where Akron police operated a twelve-cell jail at South Main Street and Quarry (now Bowery Street). Sheriff Frank Kelly had secretly whisked Peck to Cleveland's jail for safekeeping earlier in the day, but the stubborn vigilantes refused to believe it.

Hooligans stole the Akron department's pride and joy, the world's first motorized police wagon, a 5,500-pound, battery-powered vehicle built by city electrician Frank Loomis in 1899, and dumped it unceremoniously into the Ohio & Erie Canal.

Refusing Chief Hughlin H. Harrison's orders to disperse, the mob threw rocks and bricks, shattered windows and formed a battering ram to smash down the city building's door. From second-floor windows, officers fired shots into the seething crowd, killing two onlookers—Glen Wade, ten, and Rhoda Davidson, seven—and wounding several men. The revenge-minded mob exploded in violence, storming the building, setting it ablaze and blasting it with dynamite.

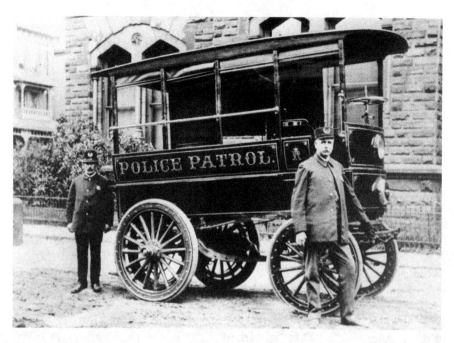

Akron had the world's first motorized police wagon, a 5,500-pound, battery-powered vehicle built by city electrician Frank Loomis in 1899. *Courtesy of Akron Police Museum.*

Escaping through a basement door, Harrison fled in terror. Flames licked the night sky as the city hall and adjacent buildings shuddered and collapsed. When the state militia arrived early the next day to restore order, it was eerily quiet. Wire dispatches appeared in newspapers across the continent, shaming the city:

> *When day dawned in Akron this morning it revealed a scene of desolation and the evidences of violence and lawlessness unparalleled in the history of the city. The rioters had done their awful work and disappeared.…The city building was a heap of smouldering ruins and beside it steamed the water-soaked ashes of Columbia Hall. The chief had left the city. The police force of the city was disorganized and scattered.*

Akron was left to pick up the pieces. Chief Harrison resigned in humiliation after losing the respect of officers and citizens. Patrolman John Durkin, forty-two, a seasoned cop who joined the force in 1883, was installed as chief for $1,200 per year. Dozens of rioters were arrested and sentenced for their roles in the awful melee. Louis Peck was convicted of rape in a hasty trial

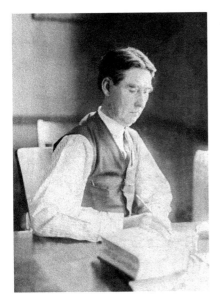

Chief John Durkin, a seasoned cop who joined the force in 1883, modernized the Akron Police Department following the deadly riot of 1900. *From the* Akron Beacon Journal.

without legal counsel, sentenced to life imprisonment and spent thirteen years at the state penitentiary before winning a full pardon over lingering doubts of his guilt and due process.

Upon being promoted in December 1900, Durkin announced that he would modernize the police department and regain the public's confidence. "I will prepare and recommend to the board of city commissioners a more complete system than the present one to regulate the work and duties of patrolmen," he said. "It will take some time to get everything in perfect working order but I am certain that every officer on the force will do everything in his power to assist in making it up to date and metropolitan."

An Irish American officer who spoke with a brogue, Durkin stood about six-foot-three and was known to be an affable fellow but hard as nails when necessary. He pleaded with the city for additional manpower—"To have a strong department in Akron we must have more officers"—and was rewarded with the hiring of a dozen cops, bringing the force's size to forty-eight. Breaking with tradition, Durkin declined to wear a uniform. "The time was when it was quite the thing for a chief of police to appear in a gay uniform bedecked with gold braid and brass buttons, but modern chiefs in all metropolitan cities are content to appear in a modest, ordinary, everyday suit of clothes," he explained.

Durkin reassigned beats and ordered officers to shave off their mustaches to present a more tidy appearance. He established a traffic bureau, vice squad, cruiser squad and Bertillon criminal identification system and presided over the 1909 opening of a new police station at South High Street and present-day Bowery. Thanks to Durkin's efforts, the Akron Police Department rose from the ashes of the 1900 riot and emerged as a modern, professional force. Criminals beware.

With only two days to go until Christmas 1917, Patrolman Guy Norris walked the midnight beat in his South Akron neighborhood. It was

supposed to be a season of joy, but the city wasn't following the program, with shootings, stabbings and muggings—so much for peace on earth and goodwill toward men.

The twenty-eight-year-old officer met a lot of rugged characters on the job—it came with the territory. His beat included Hell's Half Acre, a notorious district south of downtown where young hoodlums from rival ethnic groups often battled for supremacy. Located around South Main Street, Thornton Street and Washington Street, the zone owed its hellish nickname to the nineteenth-century Akron Iron Company, whose twenty-four-hour blast furnace tinted the night sky with an eerie, reddish glow until an arsonist burned the place to the ground in 1897.

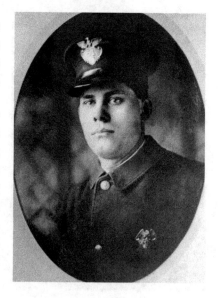

Patrolman Guy Norris, regarded as one of the toughest cops on the force, joined the Akron Police Department in 1915. *From the* Akron Beacon Journal.

A rugged character himself, Norris developed a reputation as one of the toughest cops in the department during two and a half years on the job. The former electrician, a native of Freedom Township in Portage County, joined the Akron force in 1915 after working at the Quaker Oats factory.

In those days, officers were issued a badge, club, whistle, cap and helmet but had to pay for their uniform and gun. They patrolled their beats by foot—after all, there were only four automobiles in the entire department—and got to know the neighborhoods one face at a time, learning the names of residents and business owners and observing the comings and goings of strangers.

When gamblers set up shop in the basement of John Oeschner's tailor shop, Norris raided the business single-handedly and made seven arrests. When teens Dan McGowan and Charles Martin went on a joyride in a stolen automobile, he whistled them to a stop and confiscated the vehicle on South Main Street. When inebriated New York traveling salesmen Avery Hickey and Albert Streeter engaged in fisticuffs in the street, he broke up the fight and let them sleep it off in the city jail.

Norris made headlines twice during his first two years on the job, and both times, he wished he hadn't. As a rookie of only a few months, he nearly lost

his life late one night in July 1915 while patrolling his original beat on North Hill. As Norris later told his superiors, he was passing the Otto Schwarz home on East Tallmadge Avenue at 1:25 a.m. when a mysterious noise caught his attention. Schwarz, a Goodrich employment manager, had also heard the noise and rose from bed to investigate. As Norris crept closer, Schwarz heard approaching footsteps, assumed a burglar was trying to break into his home, opened a window and fired a revolver. Norris felt a bullet whiz past his ear.

"Hey, what's the matter with you?" Norris cried out.

"Oh," Schwarz replied after poking his head through the window and seeing the cop. Norris and Schwarz looked around but couldn't find the source of the earlier noise. "I just wanted to scare the fellow, anyway," Schwarz told the officer about the imaginary burglar. "I didn't shoot right at you."

A year later, Norris was called on the carpet at Safety Director Charles R. Morgan's office to explain a 1916 altercation on Miami Street in South Akron. Norris and Patrolman James J. McFarland went to the home of Star Drill Company employee Henry George in search of a vandal who shattered the front window of a South Main Street saloon. George told the officers they had the wrong address, but he said they pushed him aside, roughed him up and ransacked the house in a futile attempt to find the suspect.

George claimed that Norris punched him several times, knocking out a tooth and giving him a black eye. However, the patrolman told his bosses that the resident injured himself when he made a mad rush at the officer and ran into his open hand, which the patrolman had extended to halt him. George filed a $10,000 lawsuit against the two cops, but local newspapers didn't report the outcome. The case may have been settled quietly out of court. Or maybe it was dropped during the citywide crisis that followed.

Two days before Christmas 1917, Norris trudged his usual route. It was a clear night with days-old snow on the ground, a first-quarter moon and frosty temperatures in the twenties. Norris was only a few blocks away from his Grant Street home in the Wolf Ledge district, where his wife, Hulda, and sons Russell, three, and Ralph, one, presumably were asleep.

He had started the shift at 7:00 p.m. and checked in with headquarters at the top of each hour. Around 1:30 a.m. on Sunday, December 23, the six-foot, 190-pound patrolman discovered six men in a heated dispute in front of the Akron Brewing Company at Voris Street and South High Street (a block that was later renamed South Broadway). The patrolman interrupted the quarrel between three Hungarians and three Italians. The Hungarians complained to the officer that the Italians tried to pick a fight with them, and

one had flashed a handgun. The patrolman noticed that the Italians were hurrying north, so he followed them and ordered them to stop. "Throw up your hands!" Norris ordered.

It was a common procedure among Akron police to stop suspicious-looking men to search for weapons. Norris lost track of all the times he had patted down men for knives and guns. This time, however, the routine assignment turned horribly wrong. As Norris searched the pockets of one of the Italians, another reached into his overcoat, pulled a revolver and shot the patrolman in the chest from about three feet away. The blast echoed through the neighborhood. Norris collapsed to the sidewalk as the hoodlums escaped east on Thornton Street.

Julius Kordos, who operated a coffeehouse on South High Street, heard the gunshot and went outside to investigate. He found a dark heap in front of a home at 778 South High Street. The bloodied officer was alive and alert but paralyzed from the shoulders down, with a bullet in his spinal cord. Kordos called police.

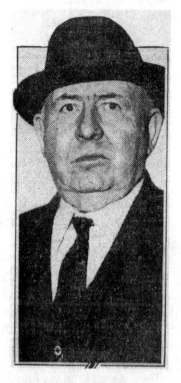

Detective Bert Eckerman, a member of the force since 1903, kept a vigil at the bedside of mortally wounded Guy Norris in December 1917. *From the* Akron Beacon Journal.

From a bed at Akron City Hospital, Norris told Detective Bert Eckerman what had happened. He couldn't provide a good description of the gunman or accomplices, though, other than to say they were Italians. Police Chief John Durkin put fifteen patrolmen and two captains on the case. The dragnet turned the neighborhood upside down but failed to turn up any clues. Even the three Hungarians who came forward to corroborate the patrolman's story were unable to identify any suspects.

Eckerman stayed at Norris's bedside all day and night. The patrolman lost consciousness around 9:30 p.m. Sunday and was pronounced dead at 4:30 a.m. Monday, Christmas Eve. He was the first officer to die in the line of duty in the forty-five-year history of the Akron force.

"He was literally afraid of nothing," a grief-stricken Eckerman told the *Akron Beacon Journal.* "He was always ready for the most hazardous work, and kept his beat in the best of order at all times."

Overlooking the lawsuit from a year earlier, Safety Director Morgan eulogized, "There was never a complaint against him, and I considered him one of the very best policemen we had."

After a somber Christmas, most of the police force turned out for Patrolman Guy Norris's funeral at 2:00 p.m., December 27, at Concordia Lutheran Church. Hundreds of officers, relatives and friends packed the memorial service. Patrolmen Gethin Richards, Fred Viereck, Paul Krause, Edward Hieber, Verne Cross and Harry Black served as pallbearers. Norris was buried at Mount Peace Cemetery.

Chief Durkin pledged that the department would find the killer and bring him to justice. Summit County commissioners offered a $500 reward. Yet the trail soon grew cold.

"In an attempt to locate the murderers of Patrolman Norris, Akron police are putting every suspicious-looking foreigner they find through the third degree," the *Beacon Journal* reported on December 29. "Saturday morning, the chief had two men at headquarters, and for over an hour, tried to get some information out of them, but finally gave it up. While announcing that it was 'a bum steer,' the police are still holding the suspects for further investigation."

Police prosecutor Owen M. Roderick urged officers to wage a campaign against illegal guns. He estimated that nearly half of Akron's foreign population carried concealed weapons, although he didn't explain how he determined that figure. He proposed weekly sweeps in saloons to search every man for weapons. Although it didn't come to that, officers did turn up the heat on immigrants, especially Italians.

No one ever was put on trial for the murder of Patrolman Norris. In a few short weeks, though, the motive for the slaying became terribly clear.

Akron was still in deep shock as 1918 arrived. Officers had trouble comprehending the tragic death of their friend and colleague. It simply was unthinkable that anyone would kill an Akron officer, a crime that had never before been committed in the city. And then the unthinkable happened again.

ANOTHER AMBUSH

I f Hell's Half Acre was the trouble spot of South Akron, its northern counterpart, Furnace Street, was a hundred times worse. The crowded neighborhood just north of downtown was a rough-and-tumble district where gambling joints, dens of iniquity and houses of ill fame ran full tilt beside working-class homes, mom and pop stores and other legitimate businesses.

Furnace Street owed its name to the Cuyahoga Furnace, an 1816 smelting plant that manufactured plows and other farming equipment along the Little Cuyahoga River. In the nineteenth century, the neighborhood was nicknamed Dublin because it housed Irish laborers who helped dig the canal. New waves of European immigrants, including a colony of Italians, made Furnace Street their home in the early twentieth century.

Patrolman Edward J. Costigan walked the district for most of the three years that he had been an Akron officer. The unmarried thirty-nine-year-old cop lived on Mount View Avenue with his widowed mother, Catherine, and four of his six sisters from their nine-sibling Irish family. Before joining the force, he worked in the mechanical department at the *Akron Press* newspaper.

The six-foot, two-hundred-pound Costigan was a no-nonsense officer who commanded respect in the city's "tenderloin district." The Furnace Street neighborhood had more than one hundred homes, twenty restaurants, fifteen saloons, ten billiard halls, six hotels and dozens of small businesses, including grocery stores, coffeehouses, barbershops, cigar stores, meat markets, tailor shops and confectioneries.

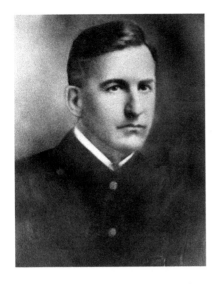

Left: Patrolman Edward Costigan joined the force in 1914 and was a no-nonsense officer who commanded respect in Akron's "tenderloin district." *From the* Akron Beacon Journal.

Below: It's another gray, sooty winter day in Akron in this 1919 view overlooking the rough-and-tumble Furnace Street neighborhood. *Author's collection.*

Quarrels, brawls, stabbings and shootings erupted with regularity on the street. One afternoon, Costigan heard a gunshot in the 120 block of Furnace and rushed to investigate. A young Italian man bolted out of a bar and complained that a neighbor had just tried to shoot him. While Costigan talked to the witness, the angry gunman walked up and shot the snitch dead. Bang! Just another day on Furnace.

Costigan had no qualms about stopping suspicious-looking people and frisking them for weapons. The searches stirred resentment in the neighborhood because some immigrants felt they were being unfairly

targeted. Behind the cop's back, neighborhood ruffians began to call Costigan the "Red Policeman," or "Red," a disparaging nickname based on his ruddy complexion.

Patrolman William McDonnell had known Costigan for most of his life and was his closest friend on the force. As youngsters in Akron, they attended grade school together and occasionally played hooky to go fishing. McDonnell joined the force on St. Patrick's Day 1913, and Costigan followed his footsteps.

"Big Will," so called because of his 235-pound girth, walked an adjacent beat on North Howard Street from Federal Street (later Perkins Street, now Martin Luther King Jr. Boulevard) all the way to the Gorge between North Hill and Cuyahoga Falls. "Anything could happen down there—and usually did," McDonnell recalled years later. "We didn't have cruisers or radios in those days, so I seldom got as far out as the Gorge. I usually had enough to keep me busy downtown."

When their shifts ended, McDonnell and Costigan usually met up at Furnace, the nexus point between their two beats, and walked back to police headquarters at South High Street and East Bowery Street. On the cool, clear evening of Thursday, January 10, 1918, they made plans to stop at the East Ohio Gas Company office on High Street to pay their heating bills. "It's our last chance," Costigan told McDonnell.

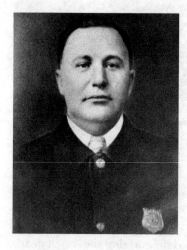

Patrolman Joseph Hunt was a rookie officer of four months who had a wife and three young children. *From the* Akron Beacon Journal.

Patrolman Joseph H. Hunt, a German American rookie who joined the force in September after working as a millwright at Quaker Oats, agreed to go with them. It had been a long day on Furnace Street. The thirty-three-year-old cop had paid a few visits to saloons to persuade unsavory patrons to stop "molesting women." In one heated confrontation, a hoodlum warned Hunt that he had better watch his step in the neighborhood.

The three patrolmen set off around 7:00 p.m., but a pedestrian stopped McDonnell to tell him that a drunken man was unconscious in the middle of North Street. McDonnell told Costigan and Hunt to go pay their gas bills and he'd meet them later that evening. It was cold and gloomy as the

two cops walked north on High Street past the giant shed for Northern Ohio Traction & Light Company's new interurban terminal.

They did not notice three shadowy figures trailing them from Furnace Street. One stayed a block behind to serve as a lookout while the others quickened their pace. Costigan and Hunt were passing the Union Fireproof Storage Company at 41–45 North High Street when they were gunned down at 7:15 p.m. "We didn't hear anyone following us," Hunt later said. "In fact, we didn't hear or see anything unusual until we were shot in the back."

Two men with .38-caliber pistols pumped steel-nosed bullets into the patrolmen from a few feet away while a third man watched from a distance. Hunt said he felt a twinge in his back and legs, wheeled around, drew his revolver and returned fire. "I guess I emptied it, but do not know whether or not I hit them," Hunt said. "Probably I didn't because I was becoming wobbly on my pins. I believe the three were Italians. Two of them wore dark overcoats and soft hats. I'm not sure about the third one, although I noticed that he wore a cap. They ran north on High Street."

Costigan was shot four times in the back and collapsed facedown on the red-brick street. Five bullets struck Hunt—two in the right leg, two in the left arm and one that pierced his intestine and gallbladder and exited below his navel.

Marie Azar, who lived at 55 North High Street, testified that she heard gunshots, rushed to her front porch and saw two men run past while an officer fired at them. She hurried to Costigan's body, but there was nothing she could do. "I thought if he was alive I would give him air, and then I called for help," Azar said. "Hunt was staggering, ready to fall, when some men caught him. He said, 'Well, boys, they got me.' Then the machine came on the scene and took the officers away."

The patrolmen were rushed to Akron City Hospital, where Costigan was pronounced dead on arrival and Hunt underwent surgery. Police Chief John Durkin sounded an alarm: "Get every man tonight who cannot give a good account of himself. Get the men who killed Costigan and shot Hunt."

By the time Patrolman McDonnell got to North Street, friends had already carted off the intoxicated man, so the officer phoned headquarters from a call box around 7:30 p.m. and received the horrifying bulletin that two cops had been shot on High Street, only a five-minute walk from the police station.

"I knew immediately that it was Ed and Joe," McDonnell told a reporter the next day. "If I had been with them, I would have got it, too, and would have been in the morgue or hospital this morning." He regretted not being

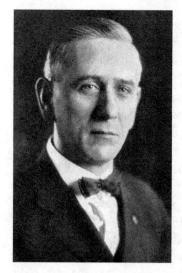

Sheriff Jim Corey served from 1914 to 1918. His office was in the Summit County Jail between South Broadway and South High Street. *Author's collection.*

with his comrades to fight the gunmen, though. "I think if I hadn't gone back to tend to that drunk, the three of us might have at least wounded one of them," he said.

Akron had never seen a frenzied manhunt like the one that transpired that weekend. Chief Durkin ordered every cop to hit the streets in search of the killers, turning the city into zones and scouring neighborhoods from block to block—beginning with Furnace Street. "Practically every foreigner in the city who could not give an account of himself during the period from 5 until 8 o'clock was rounded up and brought to headquarters as a suspect," the *Beacon Journal* reported on January 11. "Coffee houses were visited, every saloon, pool room and other meeting place in the city was inspected and suspects gathered in."

Officers barricaded roads, halted drivers and searched vehicles. They stopped trains, frisked passengers and interrogated "suspicious-appearing characters." Sheriff Jim Corey had Summit County deputies raid gambling parlors and shady resorts on the outskirts of town.

Detective Bert Eckerman must have experienced ghastly déjà vu as he kept a vigil at Hunt's bed less than three weeks after doing the same for Patrolman Guy Norris. Eckerman and H.B. Kerr, city editor at the *Akron Press*, interviewed a wheezing, moaning Hunt for details about the ambush. "I guess I'm done for," Hunt told the men. "Ain't it hell to be a policeman? And I've only been on the force four months. There's the wife and three little kiddies, too."

Distraught wife Adale Hunt joined her husband at his bedside and tried to keep a brave face. She hadn't wanted him to become a cop because she feared something terrible might happen. During the first few weeks after Joe joined the force, she barely got any sleep at their Bellows Street home. Now her worst nightmare had come true.

The officer battled valiantly for two days at the hospital, even showing signs of improvement, but the internal damage was too severe. Patrolman Hunt died at 10:00 p.m., Saturday, January 12, leaving behind his thirty-year-old widow and sons Leonard, eight; Louis, five; and Laurence, one.

Bells tolled the next week as two patrolmen were laid to rest. Hundreds attended Costigan's funeral Monday at St. Vincent Catholic Church, where Reverend John J. Scullen eulogized, "He not only proved his worth in the fulfillment of his duties, but the reflection of his whole life makes his fate the more appalling."

Pallbearers were Gus Baehr, Jack Cardarelli, Thomas Costigan, Charles Costigan and Patrolmen William McDonnell and Grover Starkey. Honorary pallbearers from the police force were Ed Heffernan, John Duffy, Frank McAllister, Patrick Sweeney, Patrick Conley and George Fatherson. "They were two of the best boys ever on the force," Chief Durkin said.

Costigan was survived by his eight siblings—Catherine, Margaret, Thomas, Anna, Bridget, Julia, Mary and John—and sixty-seven-year-old mother, Catherine, whose despair was so great that she died broken-hearted six weeks later. They were buried in a family plot at St. Vincent Cemetery.

Hundreds gathered again Wednesday morning at St. Mary Catholic Church for Hunt's funeral. In his eulogy, Reverend Joseph O'Keefe noted, "A little more of the law of God practiced in the everyday life of the world, more regard for the Ten Commandments, would make such terrible murders unheard of—for with regard for God's law, civil law could be more readily enforced."

For the second time that week, McDonnell, Heffernan, McAllister and Starkey served as pallbearers, along with Officers Adolph Oberdoerster and Frank McGuire. "It is seldom we are fortunate enough to get a man like Costigan," Captain Alva Greenlese said.

Uniformed police led a somber procession to Holy Cross Cemetery, where Hunt was buried. Following the ceremony, the cops wiped away tears and returned to work. There was no more time to mourn. Gangsters were hunting Akron officers and had to be stopped.

"We'll get them," Detective Eckerman vowed.

KING OF THE UNDERWORLD

While Hollywood villains flickered on the silent screens of Akron movie theaters, a real-life menace walked the streets. Rosario Borgia held the town in his powerful fist and tried to crack it like a walnut. Akron was the "City of Opportunity," and Borgia seldom missed an opportunity.

The twenty-four-year-old Italian immigrant ran the rackets with a ruthless band of gangsters whose illicit operations included gambling, prostitution, robbery, safecracking, extortion and murder. If other hoodlums tried to horn in on business, they disappeared. Akron newspapers published articles about unidentified men whose slashed, bludgeoned, bullet-riddled bodies were fished out of rivers or dug out of shallow graves.

Borgia had so many aliases that no one could keep them straight: Russell Berg, Russell Burch, Mike Burga, Joe Filastocco, Joe Philostopo, Pippino Napolitano, Joe Neapolitan, Rosario Borge, Rosario Borgi and Rosario Borgio. It's possible that none of those was his real name, although he listed his parents as Giovanni and Maria Borgi on at least one legal document.

He was born in 1893 in the tiny village of Sant'Agata del Bianco, in Cosenza, Calabria, in southern Italy, and immigrated to the United States in 1910, arriving at New York's Ellis Island aboard the ocean liner *Duca d'Aosta* and settling in Akron by 1915. Borgia pulled his first thefts as a little boy and was a hardened criminal by adolescence. He may already have been a killer, too. A tale whispered in Akron speakeasies was that Borgia fled Italy because he had murdered his uncle, a police officer who threw him in jail for stealing. Whether true or apocryphal, the story added

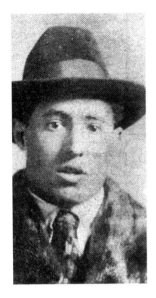

Furnace Street gangster Rosario Borgia, a native of Calabria, Italy, wears a hat and a fur-lined coat in this 1918 police photo. *Courtesy of Akron Police Museum.*

to Borgia's menace in America—stay away from that guy; he'll kill anyone who crosses him, even relatives.

Borgia was a large man, solidly built, with a lightning temper and intimidating presence. He fought briefly as a professional wrestler before giving up the sport and pursuing other interests, namely women. The Furnace Street red-light district beckoned many Akron newcomers, and Borgia was no different. "White slavery" was a lucrative business, and Borgia wanted a piece of the action.

Reverend Charles Reign Scoville, an Indiana evangelist and Hiram College graduate, warned Akron residents about the dangers of prostitution (and men like Borgia) during fiery sermons at a one-month tabernacle on Cherry Street in 1915. The preacher said that young women risked going astray through coquettish behavior that attracted evil-minded fiends. "Flirtation is next door to damnation, and the girl who sits in public rolling her eyes to see who's looking at her is flirting as hard as she can," Scoville said. Speaking against disorderly houses, Scoville told an Akron crowd:

We must wipe out segregated districts and secure law enforcement. No big city has any more excuse for having a tenderloin section than a small country village. Not as much. Most inmates of these houses can say the Lord's Prayer as well as you or I, and that makes me sick at heart. It shows that they were under the influence and teaching of good parents and a Sunday school some time in their lives. They have actually been stolen and there ought to be a life sentence for any man who steals a pure girl.

Borgia's first known arrest in the Midwest was on July 7, 1915, on a charge of taking an Ohio girl to Detroit for "immoral purposes." Six months later, he married Filomena Matteo, twenty-five, an Italian immigrant, before Justice of the Peace Charles W. Dickerson on December 22 in Summit County. On their marriage license application, they listed their occupations as "restaurant owner" and "waitress."

Streetcar tracks run up the middle of North Howard Street in 1919. Looking north, this view is close to the site where Rosario Borgia operated his so-called restaurant. *Author's collection*.

The couple opened a "soft-drink establishment" in their home at 93 North Howard Street, not far from Furnace Street, and brought in young women to separate rubber workers from their cash. Filomena, who could not read or write English, dutifully turned over the money to her husband. Beat cops referred to Borgia's wife as "Dago Rose," an Italian slur, and suspected that she was serving more than soft drinks at the business.

Borgia was livid when police conducted a Saturday night raid on the brothel on February 12, 1916. Patrolmen Will McDonnell and George Werne charged Borgia with keeping a questionable business, and they charged his newlywed wife and two other women with inhabiting it. They all were freed on $100 bail.

Perturbed but undeterred, Borgia relocated the "restaurant" to Barberton's Mulberry Street, where his wife continued to supervise the "waitresses." Borgia, hardly a paragon of virtue, had the audacity to file for divorce in June 1917, alleging that his wife was "guilty of adultery several times." The case was dismissed when the couple reconciled.

Ostensibly, Borgia was a barber by trade and worked at a shop on Washington Street, but illicit activities were far more profitable. He diversified his criminal portfolio, surrounding himself with a band of young, like-minded Sicilians who excelled in breaking the law. Money, women, power—they could have it all if they followed Borgia's lead. The gang liked to hang out at Joe Congena's pool hall at 121 Furnace Street, where the men occasionally retreated to a back room to make big plans behind closed doors.

The sledgehammered safe at the Acme store on North Hill? That was the work of the Furnace Street gang. The nightclub with the slot machines, punch boards and dice games? That cash went straight to the Furnace Street gang. The floating body in the Cuyahoga River? That guy knew too much and talked too much, so the Furnace Street gang had to silence him.

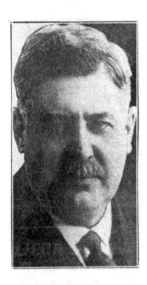

Detective Harry Welch discovered that Furnace Street residents and business owners were too frightened to talk about gang activity in the neighborhood. *From the* Akron Beacon Journal.

Detective Harry Welch couldn't find any Furnace Street residents or business owners willing to talk to officers about the escalating crime wave in the neighborhood. The locals feared for their lives and didn't want to risk being labeled

as squealers. Even when promised police protection, potential witnesses clammed up.

"Victims of the plundering gang continued to shake their heads slowly and refused to identify anyone," true-crime reporter Will H. Murray wrote decades later. "One shopkeeper showed Welch the gruesome drawing of a skull which he had found on his doorstep the day after he had been held up. 'The sign of the Black Hand!' he shivered. 'To speak is to die.'"

At least five unsolved murders were attributed to Borgia, but he was never convicted of any of them. Nobody wanted to be added to the list. "Rosario Borgia of Barberton is the ringleader of this band of Italian toughs," theorized George Martino, an Italian American private detective from Akron. "He's the typical Black Hand captain. He toils not, neither does he spin, and yet he's always well-dressed and has plenty of money."

The flashy gang wore ill-gotten wealth on its sleeve, parading around in three-piece suits, silk shirts, flowery ties, wide-brimmed hats and polished shoes. Coiffed, dapper and clean shaven, Borgia led the way

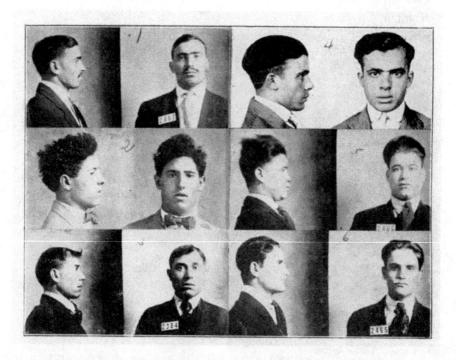

The Akron Police Department takes mug shots of the Furnace Street gang in 1918. *Clockwise from top left*: Pasquale Biondo, Frank Mazzano, Lorenzo Biondo, Anthony Manfriedo, Paul Chiavaro and Rosario Borgia. *Courtesy of Akron Police Museum.*

with roguishly good looks—an oval face, olive skin, black hair, dark eyes, prominent nose, full lips, jug ears, muscular shoulders and, truth be told, not much of a neck.

More than a dozen members belonged to Borgia's crew, but he trusted some more than others. There was Lorenzo Biondo, nineteen, alias James Palmieri, alias Jimmy the Bulldog, a square-jawed bruiser and two-fisted enforcer who always did what the boss ordered as long as the money kept rolling in; Pasquale Biondo, twenty-one, alias Bolo Mazza, alias Patsy Brando, a petulant hooligan, slight of build, with receding hair, a unibrow and wispy mustache and who, despite the surname, angrily insisted he wasn't related to Lorenzo; Paul Chiavaro, twenty-four, alias Paulo Chivoro, a nebbish sadist who used dum-dum bullets to inflict more damage and coated them with oil of garlic to make the flesh blister; and Anthony Manfriedo, twenty-one, alias Tony Monfredo, a hard-luck underling who refused to kill a friend despite Borgia's orders, so gang members shot him through the hand, stabbed him in the stomach, robbed him of forty dollars and threw him over a cliff into the Gorge—only for him to crawl out, beg for forgiveness and rejoin the group.

Last but not least was the runt of the litter, Frank Mazzano, eighteen, alias Joe Pelo, alias Nicol Matolli, a five-foot-five thug who was as vicious as he was vain. The Sicilian arrived at Ellis Island in 1914, lived for a year in New York and then settled in Akron about 1915. An elevator operator at Goodrich, Mazzano quit his blue-collar job after getting a haircut from Borgia, who persuaded the teen to come work for him for ten dollars a week. Rosario had an impressionable protégé who could be groomed into a right-hand man.

With exaggerated features, Mazzano's face looked like it was sculpted from clay. He had large brown eyes, bushy eyebrows, puffy lips and a jet-black pompadour that he carefully combed. In a coat pocket, Mazzano carried a small mirror that he pulled out frequently to survey his looks and groom as needed. Sullen one moment and cracking jokes the next, Mazzano was a typical, rebellious, girl-crazy teenager who just happened to have psychopathic tendencies.

With Mazzano in his thrall, Borgia sent the kid to Mansfield in April 1917 to stalk Carlo Bocaro, age twenty-four, a rival gangster and white slaver from Calabria. Borgia paid for Mazzano's train fare and gave him money to buy a gun. "Rosario told me to kill him," Mazzano explained later. "He knew him. They came from the same town in the old country. Rosario said he was a bad man and to shoot him."

Shortly before midnight on April 14, Mazzano ambushed Bocaro at Sixth and Diamond Streets in Mansfield, shooting him twice in the head and twice in the legs. Unbelievably, Bocaro survived the attack, and Mazzano later joked that he must be a terrible shot. Borgia sent hit man Frank Valona to finish the job, and Bocaro died in a fusillade of bullets on November 15, suffering three more gunshot wounds at close range. Valona was convicted of second-degree murder and sentenced to life in prison. Mazzano pleaded guilty to assault and battery and was freed on bond after "out-of-town Italians" fronted the necessary $500.

Patrolmen Ed Costigan, Will McDonnell and other Akron officers knew that Borgia was up to no good, so they made life difficult for him. Vice raids and frequent harassment put a dent in the kingpin's business. Because Borgia had once been fined $100 for carrying a concealed weapon, Costigan made it a habit of frisking him whenever he saw him.

"The Borgia gang didn't like Costigan and me," McDonnell recalled. "Every chance we'd get, we would search them and come up with a knife or a gun. Then they'd be fined. It became pretty annoying to them….Then one morning we noticed three strangers walking up and down the street, giving Costigan and me the eye. They made three trips up and down. We didn't think too much about it at the time."

Borgia greeted officers with feigned affection when he saw them, but deep inside he seethed with anger. "I hate them! I hate them!" he told his gang, a fixation that may have begun with his uncle. Borgia was particularly obsessed with Costigan, the "Red Policeman."

In late 1917, he hatched a plot to teach the meddling cops a lesson by systematically ambushing them on the streets and putting a bounty on their heads. If necessary, the gang could stage holdups and attack the cops who responded to the calls. Patrolman Norris was the first to die. Costigan and Joseph Hunt were next.

In his usual threatening manner, Borgia ordered three of his men to take care of Costigan—or else. He handed guns to Pasquale and Lorenzo Biondo, pointed to the officers on Furnace Street and told Anthony Manfriedo to serve as lookout on January 10, 1918. "Rosario told me I would be paid $150 for killing 'Red.' This was the same night, a half-hour before the murder," Pasquale Biondo later testified. Borgia said he was tired of being searched and wanted Costigan dead. Then Borgia gave the Biondo men an ultimatum: "You kill him or I'll kill you."

The men quietly followed Costigan and Hunt up the High Street hill while Manfriedo stood watch in the gathering darkness. *Blam blam blam blam blam!*

Pasquale blasted Costigan, while Lorenzo gunned down Hunt. The gangsters ran back toward Furnace Street, dodging gunfire from the mortally wounded Hunt, and hid at an undisclosed location for several days as police interrogated foreigners across the city.

After reading about the slayings in the newspaper, Borgia secretly arranged to meet the killers in Frank Mazzano's cellar on Cross Street. "You did good work," he told them. Taking out a wad of cash, he gave $100 apiece to the Biondos and $50 to Manfriedo. Pasquale didn't know until later that he was shorted $50 of the promised $150. "I didn't count the money then, but I counted it after I left the house," he said.

Summit County commissioners offered $3,000 for information leading to the arrest of the murderers whose brazen crimes had made national headlines. It was a tense, frightening time to live in Akron. Killers were on the loose, and no one knew when they might strike again.

When officers canvassed Furnace Street and Howard Street and quizzed Borgia about the shooting of Costigan and Hunt, he denied any knowledge. "I was miles away," he said. "They were always picking on me. Now you start. Why don't you lay off? I don't know a thing about it."

OFFICER DOWN

At the request of Akron police, Italian American private detective George Martino began snooping around Furnace Street for any potential leads in the slayings of the three patrolmen. Martino had plenty of dealings with unsavory characters as the former owner of a Case Avenue saloon. He knew how to talk the talk and walk the walk. Plus, he was morally ambiguous.

He once was sentenced to a month in the county jail for contempt of court after shielding the identity of a larceny suspect. Another time, he was named as a suspect in a $100 shortage from the Italian Foreign Exchange Bank, where he served as secretary, but the case was settled out of court. He also was implicated in a Cleveland scheme to pocket $100 in bond money that was intended for a fugitive.

Word soon got back to the Furnace Street gang that an outsider was asking questions in the neighborhood. If Martino kept sticking his nose in other people's business, he just might lose it.

The private investigator caught wind in early March 1918 that Rosario Borgia's boys might try to bump him off. His pulse quickened one evening when he realized that some tough-looking hoodlums were following him in downtown Akron. As Martino later explained:

I had started east on Mill Street and the gang, starting from the Hotel Buchtel, trailed me. When I reached Broadway, I speeded up and instead of going over the viaduct, I dodged under and hid myself near the Pennsylvania freight house. I had my gun and was in a position where I could have

dropped them one at a time. Evidently, the bunch thought I had crossed the viaduct, because they passed overhead and turned north on Prospect Street.

Martino escaped that night, but others wouldn't be as lucky. Two months after assassinating the cops on High Street and one week after giving Martino a scare, Borgia was ready to kill again. This time his target was Sicilian businessman Giacomo Ripellino, age forty, better known as Frank Bellini, who owned a rival "soft-drink parlor" and cigar shop on North Howard Street. Bellini, whose distinguishing characteristic was a massive, sculpted black mustache, had met Borgia three years earlier and feuded with him for nearly as long. Bellini was quiet, calm and polite; Borgia was loud, boisterous and emotional. Each accused the other of tipping off authorities to their illegal enterprises, causing vice raids that put a crimp in business.

Although the men hadn't been on speaking terms for a year, Borgia signed a $10,000 contract in March 1918 to buy a home at 1014 Canal Street that Bellini had operated as a "questionable resort." Borgia invited Bellini to discuss a trade agreement on Monday, March 11, at the Furnace Street poolroom, purportedly to resolve their differences, but Bellini suspected that the afternoon meeting was a trap and declined to go. An aggravated

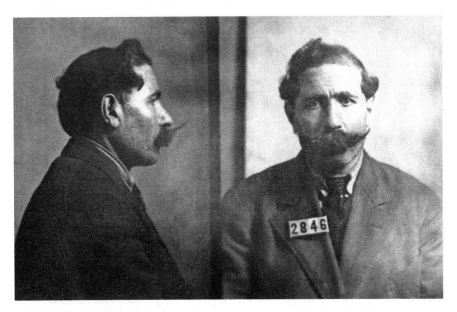

Giacamo Ripellino, better known as Frank Bellini, was the Akron nemesis of Rosario Borgia. Frank Bellini mug shots. *From the* Akron Beacon Journal.

Borgia sent Frank Mazzano to remind Bellini of the appointment, but the Sicilian again failed to show up.

With each passing hour, Borgia grew angrier. He drank wine, cracked walnuts and cursed Bellini while waiting in the smoke-filled billiard hall with Mazzano, Paul Chiavaro and other associates, including Salvatore Bambolo, Calcedonio Ferraro and Carmelo Pezzino. Borgia retreated to the back room with a few henchmen for a private meeting that lasted more than a half hour. "Borgia stopped me when I attempted to enter, told me to keep outside and shut the door," Pezzino later recalled.

Outfoxed by his nemesis, Borgia gave up on Bellini around 11:30 p.m. "Let him be tonight," he muttered. "We get him another time." Bellini's intuition was correct. If he had gone to the pool hall, he surely would have vanished like so many of Borgia's other enemies.

Borgia led his men on a night parade through downtown Akron. It was cloudy and mild but windy as they walked south on Main Street, turned east on Exchange Street and stopped at Washington Street (now Wolf Ledges Parkway), where Bambolo, Ferraro and Pezzino said good night and went home. Borgia, Mazzano and Chiavaro turned back around. All three had loaded revolvers and weren't ready to call it a night.

Walking shoulder to shoulder on the sidewalk just before 1:00 a.m., the Italians spied a dark figure drawing closer under the streetlights. George Fink, a Goodrich worker, was walking home from a friend's house when he ran into the intimidating group at the Erie Railroad tracks. The well-dressed men, wearing overcoats and fedoras, refused to make room on the sidewalk and then roughly jostled him when he tried to pass. Thinking he was about to be robbed, Fink shoved his way past the ruffians and ran.

Patrolman Gethin Richards was walking the beat about a block away near Grant Street when an agitated Fink, an old acquaintance, stopped him to complain that three men had just tried to hold him up. "Who are they?" Richards demanded. Fink pointed to the men traveling west on Exchange and replied, "There they go." Clutching a nightstick, the cop hurried off to pursue the Italians, while Fink tried to keep up.

Richards, thirty-seven, a ten-year veteran of the force, was a tall, brawny cop who was well known and well liked in his hometown. A son of Welsh immigrants, he had lived his whole life in Akron, and like everyone else, he was taken aback by the city's rapid growth. He quit his security job at the Werner publishing company in 1907 to become a police officer and made a run for Summit County sheriff in 1914 on the Progressive Party ticket. As he noted in campaign advertisements:

Patrolman Gethin Richards, a lifetime resident of Akron, was a ten-year veteran who once ran for Summit County sheriff. *From the* Akron Beacon Journal.

I do not think those who know me will question, but if elected I could and would fill the office acceptably to the people. However, this section has grown rapidly and while I used to know practically all of our people, that is no longer true. To those I do not know and who do not know me, I want to say this: I am not a politician and if I am nominated and elected, there will be no politics connected with the office of sheriff of Summit County. This important office I shall regard as a public trust and its duties shall be executed as the law directs without favor or malice to friend or foe, and at the smallest possible expense to the people.

One of more than a dozen candidates, Richards managed only seventy-four votes in the primary—at least two thousand fewer ballots than Republican hopeful Jim Corey, who went on to win the general election. The campaign over, Richards settled back into his beat.

Richards was an efficient, orderly lawman who didn't put up with any shenanigans. When he caught Alfred Minns mouthing off to pedestrians, the patrolman boxed the young man's ears and charged him with disorderly conduct. When Gus Shue ordered a thirty-five-cent meal at the Gridiron restaurant without a penny in his pocket, Richards carried him by the collar to police court. When James Porter tried to steal several coils of copper wire

from a Bell Telephone truck, Richards caught him in the act and threw him in the slammer. When Fred Hayward refused to buzz off after being accused of loitering on Main Street, Richards dragged him away on the sidewalk.

A family tragedy soon turned the patrolman's orderly world upside down. His thirty-one-year-old wife, Frieda Richards, died unexpectedly in April 1916 after falling into a diabetic coma, leaving the stunned cop with two young daughters to raise. His German-born in-laws, Fred and Marie Raeder, lived in the Richards home at 600 Grant Street and looked after the girls—both pupils at Leggett Elementary School—while their father worked nights. The daughters were home asleep at 1:00 a.m. on March 12 when Richards prepared to arrest some bad guys.

If Borgia, Mazzano and Chiavaro knew they were being followed, they didn't show it. At High and Exchange, they ambled past German-American Music Hall, whose name recently had been shortened to Music Hall because of anti-German sentiment, and turned north on Main Street. Stealthily, Patrolman Richards cut the corner to head them off, racing north on Maiden Lane and west on Kaiser Alley, while his buddy Fink walked quickly along Exchange. Richards caught up to the three Italians in front of the John Gross hardware store at 323 South Main Street.

"Hands up!" Richards ordered as the men wheeled to face him. Wielding his nightstick, the officer grabbed Borgia and began to search him for weapons. For a moment, Mazzano and Chiavaro stood frozen, unsure what to do, but the boss saw an opportunity and took it. As Richards patted down Borgia, the former pro wrestler reportedly grabbed the six-foot, two-hundred-pound cop's arm and twisted it behind his back.

"Shoot him!" Borgia shouted in Italian. "If he finds the guns on us, we will all go to the electric chair."

As Richards struggled to break free, Mazzano pulled a revolver and fired twice, missing both times and striking windows of a nearby storefront. "What's the matter with you?" Borgia hissed. "Are you trying to shoot me?"

Serving as lookout, Chiavaro yelled, "No one is looking." Mazzano steadied the Colt .38 in both hands and shot the officer once in the stomach and twice in the chest. Richards stumbled a few feet and collapsed on the brick street. George Fink turned the corner just in time to see the flashes of gunfire and dived for cover in the doorway of Joseph Ivory's foreign exchange bank. Lights blinked on in one dark apartment after another as the noisy barrage awakened neighbors. Blinds opened and curtains parted. A woman leaned out a window and screamed for help after seeing the officer writhing in the street.

IN THIS FAST-MOVING STORY OF SWIFT
STICKUPS AND BLOODY VIOLENCE, FOUR POLICEMEN
DIED—BEFORE A GANGLAND CHIEF AND HIS HENCHMEN LEARNED
THAT NO MOBSTER IS BIG ENOUGH TO DECLARE WAR ON THE LAW AND
THAT THE BEST-AIMED BULLET IS SURE TO BOOMERANG IF IT EVER HITS A COP!

A 1948 police magazine on display at the Akron Police Museum depicts three gangsters fleeing after the 1918 shooting of Patrolman Gethin Richards. The falling hat became a key bit of evidence. *Courtesy of Akron Police Museum.*

The Akron Police Department shows off its new Packard squad car in front of the Summit County Courthouse in late 1917. In the front seat are Captain Robert Guillet and Fred Work. In the back seat are Patrolmen Paul Kraus, A.O. Nelson and John Mueller. *From the Akron Beacon Journal.*

As the three gangsters ran away—Borgia fled north while Mazzano and Chiavaro scattered west—they tossed their guns aside, and Mazzano's green felt hat flew off his head. Fingerprint identification was still in its infancy in American justice, so the criminals' only concerns were getting rid of the evidence and not getting apprehended.

Fink scrambled over to Richards and grabbed the wounded officer's revolver with a vague idea of chasing the gangsters. "For God's sake, Fink, don't leave me," Richards pleaded. "I'm going to die."

Moments later, Officers Howard Pollock and Roy A. Barron screeched to a halt in the Ford squad car while investigating the sound of gunfire on Main Street. As the men loaded Richards into the car, he ordered, "Get me to the hospital as quick as you can. I'm going to die."

HUNT FOR THE GANG

With officers converging on the scene, a desperate Frank Mazzano and Paul Chiavaro ran a zigzag pattern to escape: east on Exchange, north on High Street, east on Buchtel Avenue and south on Broadway. Patrolman Oscar Wunderly gave chase when he saw two shadowy figures dart toward the railroad tracks.

If the gangsters had hoped to leap the rails and flee east toward the University of Akron, a lumbering freight train blocked their path. They had no choice but to run north.

Stumbling in the dark, Mazzano and Chiavaro followed the tracks toward the City Ice & Coal Company off Center Street (known today at University Avenue). They soon discovered that they had more to worry about than Akron police. Detective Henry LeDoux and Patrolman Edgar Bush, officers for the Erie Railroad, had been chatting in a wooden shanty when they heard the Main Street gunfire and went outside to investigate.

Several minutes later, LeDoux noticed two suspicious men approaching. One was wearing a hat, and the other was bareheaded. LeDoux calmly drew his pistol and ordered the strangers to stop. "Don't shoot!" Mazzano cried out. "Please don't shoot!"

Winded from the chase, Mazzano and Chiavaro surrendered. LeDoux discovered .38 bullets in Mazzano's pocket and a loaded revolver that Chiavaro had tossed along the tracks. Wunderly caught up to the group and took custody of the suspects, saying, "OK, they're our babies now."

Downtown Akron bustles at night in this 1917 postcard of North Main Street. This view is looking north from the Buchtel Hotel. *Author's collection.*

Akron's old police station is pictured at South High Street and Quarry Street (now Bowery) in this 1911 postcard. *Author's collection.*

The Akron officer called for the patrol wagon and loaded the men into it, stopping Mazzano when he tried to use a seat cushion to rub gunpowder residue from his hands. The young, sullen hoodlum later asked to use a washroom at the police station but was rebuffed. He initially denied being the gunman, claiming that "Joe Belo" shot the officer. Technically, that was true because Belo was his alias. Officers found his mangled .38 revolver, apparently run over by a streetcar, in a gutter near the scene of the shooting, and a .32-caliber Colt in the doorway of the Hosfield & Rinker clothing store on South Main.

"I was sitting in the chief's office talking to Mazzano when they brought in the gun that the car had run over and put in on the chief's desk," Italian American private detective George Martino later testified. "I pointed to the gun, which was a Colt .38 police special and said to Mazzano 'Is this the one you had?' Mazzano answered 'yes.'"

Officer Joe Petras transported Mazzano and Chiavaro to Peoples Hospital (known today at Akron General Medical Center) and marched them into the operating room, where Patrolman Gethin Richards was waiting. The wounded officer looked carefully at the two downcast men standing at the foot of his bed.

"That is the fellow who shot me," Richards said, pointing to Mazzano. "And that other one was with him. There was another one. Still bigger than either of these."

Ducking in and out of doorways, Rosario Borgia escaped detection as he scurried toward the Buchtel Hotel at South Main and East Mill Street in downtown Akron. It was five long blocks from the scene of the officer's shooting, but he managed to sneak back to the room he had reserved two nights earlier. Samuel Holbrook, night clerk at the Buchtel, saw Borgia arrive around 1:30 a.m. and go straight to his room but didn't think anything of it. Borgia often stayed at the hotel on nights when he didn't feel like going back to his wife in Barberton.

The gangster must have breathed a sigh of relief when he closed the door behind him. Gaining confidence with each tick of the clock, he turned off the lights and climbed into bed. Surely he had gotten away with it. About two hours later, he heard a loud, insistent knock on the door.

"Open up or I'll break in," demanded Detective Edward J. McDonnell, the kid brother of Patrolman Will McDonnell. He and Patrolman Verne Cross had checked the front desk around 3:30 a.m. to see if anyone had arrived after 1:00 a.m. The hulking Borgia, the only latecomer, opened the door and feigned ignorance when asked about the shooting. "I don't know what you're talking about," he said.

Detectives Eddie McDonnell and Pasquale "Patsy" Pappano attend the 1931 funeral of Captain Frank B. McGuire at St. Sebastian Church. *From the* Akron Beacon Journal.

Cool as a cucumber, Borgia identified himself as Russel Berg and insisted that he had dined at a chop suey restaurant around 10:00 p.m. and taken a walk to get some fresh air, but he didn't know anything about an officer being shot. When the officers escorted the suspect to headquarters for further questioning, Detective Harry Welch casually shredded the man's alias, noting, "Hello, Rosario. Haven't seen you recently."

Steadfastly denying any involvement in the attack on Richards, Borgia was taken to the city jail, where he was reunited with Mazzano and Chiavaro, along with Salvatore Bambolo, who was being held as a material witness. The sleepless men exchanged words in Italian and waited to see what would happen next.

Across town, police woke up the relatives of Gethin Richards and rushed them to Peoples Hospital. Sergeant Marvin Galloway, who spent the

Gangster Paul Chiavaro used dum-dum bullets coated with oil of garlic to make the flesh blister. *Courtesy of Akron Police Museum.*

predawn hours quizzing the wounded officer about the shooting, was present when the cop's brother Jack Richards arrived.

"They've got me at last," Gethin Richards said. "You'll look after my two little girls, won't you, Jack?"

"You bet I will," the teary-eyed brother replied.

Next, the two bewildered daughters—Marie, age ten, and Violet, age six—were ushered into the room with their grandparents. "He called them to his side and kissed them goodbye," Galloway later testified.

Richards grew weaker after surgery. By late morning, he drifted in and out of consciousness. No longer able to speak, he answered questions with a nod of his head. Relatives were at his bedside when the thirty-seven-year-old officer died at 12:36 p.m. on Tuesday, March 12. Akron had lost its fourth cop in three months.

Cletus G. Roetzel, twenty-eight, Summit County's dashing young prosecutor, called for a special grand jury about twenty minutes after Richards died. Recalling the 1900 riot, Chief John Durkin had Sheriff Jim Corey drive Borgia, Mazzano and Chiavaro to the Cuyahoga County Jail in Cleveland for their protection.

More than seven hundred people, including most of the police force, attended the funeral on Friday, March 14, which began at the family's home on Grant Street and concluded with Masonic rites at Mount Peace Cemetery, where Richards was buried next to his wife, Frieda, a stone's throw from the fresh grave of Patrolman Costigan. Reverend E.W. Simon of Trinity Lutheran Church officiated. A shield of carnations forming "28," the officer's badge number, rested on the casket.

Pedestrians and motorists halted as the hearse passed through downtown Akron. A military band led the procession, followed by sixty officers—including pallbearers Fred Vierick, Edward Hieber, Andrew Croghan, John Duffy, Verne Cross and Marvin Galloway—and then, finally, a parade of automobiles.

"There were tears in the eyes of the onlookers, and a murmured word of sympathy," the *Beacon Journal* reported. "Marie, the elder of the two children, wept her eyes red; only six-year-old Violet looked wide-eyed and wondering.

In a moment of intense grief, the aged mother-in-law was overheard to murmur, 'Has God forsaken me?'"

Later that afternoon, a grand jury indicted Borgia, Mazzano and Chiavaro on charges of first-degree murder and carrying concealed weapons. At least a dozen Akron lawyers refused to act as the defense counsel for the suspects, who returned from Cleveland and were arraigned Monday, March 18, before Summit County Common Pleas judge Charles C. Benner. A.C. Bachtel, clerk of courts, read the indictments with the aid of an Italian translator, and all three defendants pleaded not guilty.

Unbeknownst to Borgia and Mazzano, though, Chiavaro had ratted them out in the police interrogation room. After pleading not guilty, he signed a confession in Prosecutor Roetzel's office with a court stenographer and translator present but no defense lawyer.

"Who shot Richards?" Roetzel asked.

"Mazzano," Chiavaro said.

"Who else was present?"

"Borgia and myself."

"Now, in your own words, tell us what happened."

In a matter-of-fact matter, Chiavaro described the officer's murder to Roetzel:

> As we turned north on Main Street, after rounding the corner on Exchange Street, Richards ran out of the alley. Borgia was in the lead. Richards stopped us. Next to Borgia was Mazzano. I was in the rear. Richards started to search Borgia. His hands were in the air. Mazzano was about 5 feet in the rear. Suddenly, Borgia grabbed Richards' arms and stepped down. Mazzano had drawn his gun and as Borgia ducked, Mazzano opened fire. As Richards was hit, Borgia tore himself away and ran north on Main Street. Mazzano fired five shots and we ran through the alley and back toward the railroad yards.

The county prosecutor had heard enough. In the event of a conviction, he would insist on the electric chair. "It must be either the death penalty or nothing else," Roetzel told a reporter.

But the three men wouldn't be tried alone. Patrolman Pasquale "Patsy" Pappano, age twenty-five, an Italian-born cop who had been on the force for only six months, was working the case.

The six-foot, barrel-chested rookie was a native of Roseto Valfortore in Puglia, Italy, who had immigrated to the United States at age eleven. Chief

Durkin needed an officer who understood the language and the customs. "The others couldn't speak Italian and the chief said, 'We're having so much trouble with these Borgia boys and others, I want that Pappano boy with me," Pappano later recalled.

A trusted cop, Pappano cultivated informants who told him that Furnace Street gang members Lorenzo Biondo and Anthony Manfriedo were hiding out in New York City, waiting for the heat to die down in Akron. He took the news to Detective Harry Welch, who contacted Michael Fiaschetti, an Italian-born detective sergeant in the New York Police Department.

Fiaschetti was commander of the "Italian Squad," a five-man unit of Italian American cops whose mission was to investigate organized crime and bring gangsters to justice. Fiaschetti operated a network of stool pigeons to keep tabs on underworld figures. If those Akron boys were in New York, he could find out.

Manfriedo had a noticeable bullet wound, a memento from when the gang shot, stabbed and threw him over a cliff for refusing to bump off a rival. "Look for the man with a hole in his hand," Welch wrote.

JUDGMENT DAYS

Summit County judges weren't exactly lining up to put the Furnace Street gang on trial, but a small man rose to the challenge. Common Pleas judge Ervin D. Fritch, age forty-four, who stood barely five feet tall, agreed to hear the case against Frank Mazzano, the first member of the gang to face trial. "I never did belong to the Society of Scared Rabbits," Fritch later explained.

Known for his studious mind and acerbic wit, the bespectacled Fritch had deftly swatted away comments about his slight build during four years on the bench. "If I had known you needed to be a big, imposing-looking man to be an attorney, I would never have studied law," he said.

On the other extreme, Cletus Roetzel was a strapping athlete who had been a star pitcher at Buchtel College. At age twenty-five, he became the youngest prosecutor in Summit County history when voters elected him in 1916. With the nation at war, however, he enlisted in the army in early 1918 and was awaiting military training at Camp Taylor in Louisville, Kentucky, when the Mazzano case arrived.

That's why Roetzel chose his one-term predecessor, Charles P. Kennedy, age thirty-four, to serve as a special assistant. "I shall be very glad to have Kennedy with me in the trial of the case," Roetzel announced. "We get along well together and the fact that Kennedy was formerly prosecutor will make the work easier."

The reluctant, court-appointed defense team consisted of Cuyahoga Falls attorney Orlando Wilcox, age sixty-six, former president of the Akron Bar Association, and Akron lawyer Amos H. Englebeck, age thirty-two.

The Summit County Courthouse, where the Furnace Street gang went on trial, still stands today on South High Street in downtown Akron. *Author's collection.*

Nearing the end of his career, Wilcox was a folksy counselor known for philosophical musings ("I've just decided after a vast amount of study that the rat with the shortest tail is the one who gets through the hole first.") He served President William McKinley as an assistant U.S. district attorney in the Indian Territory from 1898 to 1900, trying sixty-four murder cases in Muskogee in the future state of Oklahoma. As such, he knew a losing case when he saw one.

Englebeck was an even-keeled attorney with a mirthful side, erupting in booming laughter when he found something funny. A center for the Ohio State football team in 1905–6, he stood six-foot-three and tipped the scales at 265 pounds, earning the ironic nickname "Tiny." Outside the courtroom, he was an ardent patron of the arts, once explaining, "To this day, the heart has ruled the world, and not the head."

An overflow crowd, mostly men, attended the opening of the trial Tuesday, April 9, 1918—not even a month after Gethin Richards had been killed. Sheriff Jim Corey escorted a handcuffed Mazzano through the tunnel linking the Summit County Jail to the courthouse in downtown Akron. The trial was held under heavy security, with plainclothes officers mingling with spectators in the second-floor courtroom. The drama soon fizzled as the prosecution and defense wrangled over jury selection for a week. After

disqualifying nearly one hundred candidates, the sides finally agreed on a twelve-man panel on April 17.

Judge Fritch told the jurors that he wouldn't sequester them. Despite the defense's objections, the jurors could sleep in their own beds and read newspaper articles about the trial, but they shouldn't speak to anyone about the case or form an opinion until the end.

Mazzano's legal team barely put up a defense. In opening remarks, Wilcox told the jury that he didn't even want to be there. "I am not here of my own choosing," he said. "I'm here because I was appointed to defend by the court. We are here merely to cross-question and to bring to your attention such facts as will aid you in arriving at your final conclusion."

Fritch ruled that all Italian spectators would be removed from the court during the testimony of Italian witnesses. The judge hoped the maneuver would allow witnesses to speak freely without intimidation, but it alienated the defendant, whose sister and brothers had traveled from New York to attend the proceedings. Sometimes a translator was available for Mazzano, although not always.

Freshly shaven, powdered and primped, Mazzano proved to be a dapper defendant in his neatly pressed suits, checkered vests, floral ties and polished shoes. He occasionally took out his pocket mirror in court to inspect the careful grooming of his thick, black hair. Behind him sat his girlfriend, Zella Fry, who visited him in jail each day after court was adjourned. He enjoyed reading the front-page articles about his case.

Prosecutor Roetzel called more than fifty witnesses in the trial. George Fink described his altercation with the Italians. Sergeant Marvin Galloway choked back tears as he discussed his interview with the dying officer. Jack Richards cried when recalling the hospital visit with his brother. Detective Henry LeDoux told the court how he captured the two suspects along the tracks.

By most accounts, Mazzano seemed bored and showed little emotion throughout the trial. The *Akron Press*, however, in its typical sensational style, claimed that the Sicilian defendant was on the verge of breaking down when the prosecution displayed the slain officer's bloodstained clothes in court along with morgue photos. According to the *Press*, "Frank Mazzano shuddered and his hands twitched nervously in court....His olive skin grew several shades lighter, his eyelids flickered, he moistened his lips with his tongue and nervously twined and intertwined his fingers."

In a bit of courtroom theatricality, Roetzel introduced a surprise witness in the case. J. Henry Bair, deputy sheriff at the county jail, testified that

Left: Summit County Common Pleas judge Ervin Fritch stood barely five feet tall but was a towering presence in local justice. *From the* Akron Beacon Journal.

Right: Prosecutor Cletus Roetzel led the case against the Furnace Street gang in 1918. He served two terms before resuming his law practice. *From the* Akron Beacon Journal.

Mazzano accidentally incriminated himself that week regarding a key piece of evidence: the green hat found at the scene of the shooting. As Bair testified:

> *Mazzano had been kicking because we hadn't given him all his clothes, so I told him I would get them for him. I took him down in the sheriff's office where I had his handbag with some stuff in it. He looked at that and it wasn't all. Over on the hat rack was my overcoat and hat, a soft black hat, that green soft hat, and that coat. Mazzano looked over at the rack and said, "That's my coat and hat, too." "Are you sure that's your hat?" I asked him, "Yes, I'm sure. Don't you think I know my own clothes when I see them? I'll show you." And he went over and put the hat on. "There," he says. "See, it fits." And he took it off and threw it on the couch.*

As if the dying patrolman's positive identification weren't enough, Mazzano admitted owning the hat that witnesses found at the crime scene. The vise was slowly tightening, but Mazzano declined to testify. "I'll not squeal at this stage of the game," Mazzano told a reporter.

Similarly, fellow gangster Paul Chiavaro was called to the stand, but he wouldn't testify, despite his earlier signed confession to the prosecutor.

"Who killed Gethin Richards?" Roetzel demanded in court.

"I have nothing to say," Chiavaro replied. "I don't know."

"To refresh your recollection, didn't you tell me that you saw a gun in Frank Mazzano's hand and you saw him raise his hand and saw a spurt of flame and heard the report when the policeman was coming towards you?" Roetzel asked.

"I don't know nothing and I don't know nobody," Chiavaro said. Rosario Borgia, also being held at the county jail, had sworn his henchmen to secrecy.

For the defense, Wilcox and Englebeck literally seemed to be going through the motions. They made objections here and there and postulated a nebulous theory about mistaken identity but called no witnesses who could help deflect the prosecution's constant battering. When closing arguments were made April 23, Englebeck thanked jurors and urged them to keep an open mind and give Mazzano "the benefit of every possible doubt." Wilcox jolted the courtroom by saying merely, "The defense rests."

Meanwhile, Kennedy, the assistant prosecutor, delivered an eloquent, impassioned address to the jury, saying it was their duty as American citizens to convict Mazzano. "The time has come that we must show these men who come to this city and this county for the purpose of committing crime and making a living any way except by honest work that we will not tolerate murder," Kennedy said. "Has human life become so cheap in Summit County that it may be taken with impunity on the slightest excuse or none at all? No, the time has arrived when we must let the word go out through the city, the county, the state and through the country itself that Summit County juries will not allow murderers to be sent to the penitentiary for a few years and then let them out to commit such crimes again."

The jury deliberated only forty minutes before finding Mazzano guilty on all counts. He became the first Summit County resident in nearly fifty years to face the death penalty and the first to face the electric chair. "Not one move did the prisoner, Frank Mazzano, make," the *Beacon Journal* reported. "He seemed just as unconcerned then as he has been all through the trial."

The widow and mother of Patrolman Guy Norris, the first victim, were in the packed courtroom when the verdict was read. No one ever was charged in his slaying, but they took some solace in the conviction.

Talking with reporters, defense attorney Orlando Wilcox sighed, "Defending Mazzano in this case was difficult. However, I feel satisfied that everything was done for him which we could do and we will continue to look after his interests until the case is finally disposed of."

That evening, after the verdict, Mazzano could be heard singing, whistling and humming in his cell. It was as if the young man didn't have a care in the world.

"How you feeling, Frank?" jailer Bair asked.

"Never felt better," Mazzano chirped.

"What did you think of the verdict?"

"Suits me if it suits them."

In contrast to the standing room–only crowds of the trial, the sentencing hearing was held before a small audience on Saturday, May 4.

"Have you anything to say before sentence is passed on you?" Judge Fritch asked the defendant.

"Nothing," Mazzano replied.

"There is nothing further to say that has not already been said," Wilcox clarified.

Fritch noted:

> *First, it is my duty to inform you, Frank Mazzano, that the jury in your case returned a verdict of murder in the first degree, and it is now the duty of the court to pronounce sentence upon you. It is the sentence of the law and the judgment of the court that you be taken to the jail of the county and that after thirty days you be taken to the Ohio State Penitentiary at Columbus, there to be securely confined, and on September 16, 1918, you be put to death by having a current of electricity passed through your body sufficient to cause death until death shall result.*
>
> *The court has no disposition to say anything which will make your lot harder to bear. The plight in which you find yourself and the facts brought out in the case speak far more eloquently than anything I could say. This court has tried to the utmost of its power to give you in every way a fair and impartial trial. The court has felt throughout the entire case the responsibility resting upon him very heavily, and where there was the slightest particle of doubt as to the way in which a question should be decided it was given in favor of the defendant.*

As quietly as he arrived, Mazzano returned to jail in handcuffs. The judge and prosecutor had little time to relax because Borgia's trial was scheduled the following week.

The case took an astonishing turn, though, before the reputed kingpin could set foot in court. The next day, authorities arrested two more Furnace Street gang members for the deadly ambush of Patrolmen Edward Costigan and Joseph Hunt. One week later, they nabbed another.

THE LONG ARM OF THE LAW

Akron gangsters Lorenzo Biondo and Anthony Manfriedo made an odd couple as they hid from police at a Brooklyn rooming house in New York. Biondo was gruff and grim, a brooding thug who rarely spoke. Manfriedo was pleasant and personable, a naïve lackey who loved to gab. After a few weeks of keeping a low profile, they felt cooped up in the low-rent hideout and needed a break. What would it hurt if they left their claustrophobic confines for a few hours and found a good place to drink?

Biondo and Manfriedo walked to a nearby pool hall—the natural habitat of the Furnace Street gang—and blended in with the crowd in early May 1918. They smoked cigarettes, swigged booze and loosened up. See? Nothing to worry about. They were just two guys enjoying a night out in a city of millions.

A sharp-eyed bartender happened to see a red, puckered wound on Manfriedo's hand when he ordered a drink. Manfriedo was too busy socializing to notice that the Italian bartender was suddenly watching him suspiciously and listening carefully.

The next day, the telephone rang at the office of Detective Michael Fiaschetti, commander of the acclaimed Italian Squad at the New York Police Department. "He was in my place last night," the bartender said. "Says he is coming again tonight. Looks like he'd been shot through the hand."

Fiaschetti had waited weeks for that call. After casting hundreds of lines into the water, the squad finally got a nibble. As the detective recalled years later in a 1929 article in *Liberty* magazine:

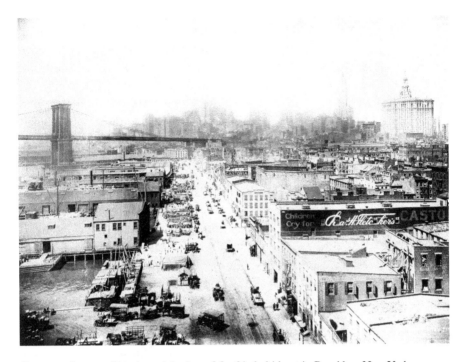

Gangsters Lorenzo Biondo and Anthony Manfriedo hid out in Brooklyn, New York, following the Akron shootings. They made the mistake of going out for a night on the town. *Courtesy of Library of Congress.*

It was the biggest stool pigeon operation I ever had anything to do with. As I've explained, it takes all kinds of birds of both sexes to make a stool pigeon system. The Italian Squad had an extensive one, and we pressed the whole of it into service. I got my staff of informers busy, and the detectives under me got theirs. Telephone calls, meetings in obscure places, cajoleries, threats—"You'll be doing me a big favor, boy," and "I'll do something for you," or "You know I've got you right where I want you, and you'd better treat me right."

Once again, the stoolies came through. After notifying Detective Harry Welch in Akron, Fiaschetti went incognito to the pool hall that evening and made small talk with patrons. He didn't have photos of the suspects, though, and didn't see anything out of the ordinary as he waded through the crowded club of Italian Americans. Only later did he realize that he had chatted with Manfriedo without recognizing him.

Detective Michael Fiaschetti, commander of the Italian Squad at the New York Police Department, helped investigate the Akron police slayings. *Author's collection.*

Learning the address of the rooming house through an informant, the detective enlisted officers to stake out the hideout. Two uniformed cops observed the inebriated men returning home around 2:00 a.m. on May 5, ordered them to halt and then overpowered them when they resisted arrest. After a quick frisk, the cops found a concealed pistol on Manfriedo, but Biondo had left his gun in his room.

Welch arrived in New York with two warrants and met up with Fiaschetti, who agreed to accompany Biondo and Manfriedo on the train trip back to Akron. It was a classic "good cop, bad cop" routine as Welch portrayed a two-fisted lawman, while Fiaschetti played up his heritage.

Fiaschetti, age thirty-six, was a native of Morolo, Italy, who immigrated to the United States as a teen in 1886 and joined the New York Police Department at age twenty-two in 1904. Lieutenant Joseph Petrosino, the revered commander of the Italian Squad, recruited Fiaschetti for the elite force and served as his mentor until a vengeful mobster gunned down Petrosino in 1909 during a visit to Italy.

Burly and bullnecked, Fiaschetti had a disarming personality when talking with criminals. He exuded empathy, which made suspects open up to him. Chatting with Manfriedo and Biondo on the train, "I was treating my two prisoners like a couple of dear old pals, laughing and joking and pretending that I took their word for it that the Akron police had pulled a dumb one in having them picked up," he said.

When Biondo dozed off under Welch's guard, Fiaschetti took Manfriedo to a different compartment and unleashed a psychological barrage to soften him up. Maybe Biondo wasn't really his friend, he suggested. Maybe Biondo had ulterior motives for hiding in New York. "Do you know why Biondo has been hanging out with you?" Fiaschetti asked. "I'll tell you. He was going to kill you."

Manfriedo angrily denied the suggestion, but as the train hurtled along the tracks, he started to lose his confidence. After all, he was only a lookout and

Anthony Manfriedo served as a lookout during the slayings of Patrolmen Ed Costigan and Joe Hunt. *Courtesy of Akron Police Museum.*

Biondo was a killer. The gang had shot him once before—a bullet through the hand—over a smaller matter. Maybe he knew too much.

If Manfriedo had any knowledge of the Akron police killings, he should confess to avoid the electric chair, Fiaschetti badgered. "Come through, Manfriedo, and you won't burn," the detective said. "Do the right thing, and you'll get off with a prison sentence."

After a moment of silence, Manfriedo caved. "It was Rosario Borgia," he said. "It all began with him."

A murmur swept the Summit County Jail on Monday as word spread about the arrival of two new prisoners. Manfriedo and Biondo took turns in the interrogation room, but instead of undergoing the third degree, they faced Fiaschetti's gentle coaxing. The New York detective translated Manfriedo's confession about the slayings of Patrolmen Ed Costigan and Joe Hunt:

> *Rosario Borgia told me one week before the crime to kill the policeman Costigan. I told Borgia I was afraid to do it. He said: "Well, you will be the lookout. You will be on the lookout while the other boys do the job." At 6:30 o'clock on January 10, I met Borgia at the poolroom on Furnace Street and met the boys, Jimmy [Lorenzo Biondo] and this other fellow [Pasquale Biondo]. We were all together at Furnace and Main streets. Then I went over towards the theater for the purpose of being a lookout. While I was on the railroad track on High Street, on guard, I heard the shots fired.*

Fiaschetti then went to work on Lorenzo Biondo, telling him the jig was up. If "Jimmy the Bulldog" knew what was good for him, he would admit his role in the slayings, the detective said. During a five-hour session before Fiaschetti and a half dozen other cops, Biondo's steely façade cracked. The normally taciturn gangster began to weep and confessed, "Borgia gave me a gun and he had another gun in his hand. 'You kill that policeman,' he

67

Lorenzo Biondo gunned down Patrolman Joe Hunt on South High Street in January 1918. *Courtesy of Akron Police Museum.*

said, pointing to Hunt who was walking up High Street with Patrolman Costigan, 'Or I will kill you.'"

Prosecutor Cletus Roetzel couldn't help but admire Fiaschetti and his tactics. "He is the cleverest man at securing confessions I have ever known," Roetzel gushed. "He is never rough, never tries to overawe or frighten the man he is talking to, but gets a confession with much speed. Why, can you believe it, he had James Palmieri crying? Fiaschetti is my idea of a high-class detective. Always the gentleman, he never seems annoyed. But if he is on a case, he won't rest."

As Fiaschetti put it, "There's nothing a cop likes better than catching the killer of a cop. It's natural; a kind of vendetta feeling."

Borgia was preparing to go to court when he heard that Biondo and Manfriedo had been captured in Brooklyn. The sensational arrests overshadowed the start of jury selection.

Meanwhile, Patrolman Patsy Pappano, Akron's answer to the Italian Squad, was following another hot tip. An informant had told him that another Furnace Street gang member, Pasquale "Patsy" Biondo (alias Bolo Mazza), was hiding at a relative's house in Sandusky, Ohio, a Lake Erie community best known as the home of Cedar Point amusement park.

Welch and Fiaschetti joined Detective Edward J. McDonnell and Sheriff Jim Corey on the drive to Sandusky to hunt for the gangster. The officers left Akron around 5:30 p.m. on Sunday, May 12, but the forty-five-mile drive to Cleveland took more than five hours because their tires kept blowing out on the rough roads. The men caught a train in Cleveland, rode nearly seventy miles and arrived in Sandusky around 2:15 a.m. Monday.

At least they had the element of surprise working for them. The officers managed to find the McDonough Street house in the dark, opened a back door and rushed up the stairs. Pasquale Biondo didn't know the house was being raided until the officers were in his bedroom.

Fiaschetti awakened the Sicilian and told him to get dressed while McDonnell rummaged through a leather suitcase on the floor. He discovered a .38-caliber handgun wrapped in an old shirt—the revolver that had been

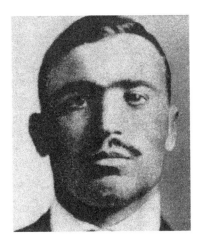

Pasquale Biondo was paid $100 to kill Patrolman Ed Costigan in 1918. He was captured at a hideout in Sandusky. *Courtesy of Akron Police Museum.*

used to kill Patrolman Costigan—and quietly gave it to Fiaschetti, who slipped it into his pocket. The gangster hadn't even bothered to get rid of the evidence.

Biondo insisted his name was Bolo Mazza, but Fiaschetti tripped him up.

"Whose bag is that over there?" he asked.

"Mine," the suspect replied.

The detective had to chuckle because the name "Pasquale Biondo" was stamped on the suitcase. The officers arrested the gangster and took him by train and automobile to Summit County Jail, where another murmur arose among prisoners. The Furnace Street gang occupied at least six cells.

With Fiaschetti serving as interpreter, Pasquale Biondo dictated a twenty-three-page confession to court stenographer Albert Walker about the slaying of Ed Costigan. In it, Biondo claimed, "Rosario told me I would be paid $150 for killing 'Red.' This was the same night, a half-hour before the murder....'You gotta do this work or I kill you.'...Sometimes he pointed a gun at me and told me that if I do not kill this Red Policeman, he kill me....And to save my own life, I killed him."

A grand jury indicted Anthony Manfriedo, Lorenzo Biondo and Pasquale Biondo in the murders of Costigan and Hunt. When arraigned before Judge Ervin D. Fritch, all three pleaded not guilty, although Pasquale technically blurted out, "Not guilty! I was forced to do it."

Arguing among themselves, the hoodlums returned to jail while the Summit County justice system turned its full attention to the murder trial of Rosario Borgia. "I'm going to pull something big in this case and I'm not going to take any chances by talking," Prosecutor Roetzel told an Akron reporter. "When the time comes, I believe my judgment in this respect will be found to be correct."

A KINGPIN TOPPLES

E ven with the unraveling of his gang, Rosario Borgia exuded confidence. He had been in tight jams before and always found a way to wriggle out. Sure, he might have to spend some time behind bars, but he'd eventually get sprung and start over. No matter what prosecutors tried to prove, Borgia hadn't fired a single shot. The boys had done all the dirty work for him.

For $3,000 in cash, Borgia hired the high-powered Cleveland law firm of Bernsteen & Bernsteen to represent him. Abram E. Bernsteen, age forty-two, and his brother, Max, age thirty-six, had been in general practice for more than a decade and were "connected with much important litigation." A.E. Bernsteen, who was unmarried and lived with his parents, was highly regarded in legal circles. As the *Journal of the Cleveland Bar Association* noted, "His swift and sure perception of the issues of a case, his ability of expressing himself with clarity carrying with it the force of sincerity and conviction won for him wide recognition as a corporate and business lawyer."

The law firm enlisted Barberton attorney Stephen C. Miller, age fifty-five, who had enjoyed a "large and lucrative general practice" since 1890, to assist with the day-to-day proceedings.

Borgia's lawyers quickly filed a motion for a change of venue, saying it was impossible for their client to receive a fair trial in Summit County because of overwhelmingly negative publicity. The team brought a stack of newspaper headlines to prove its point, but Judge Ervin D. Fritch was unmoved. The lawyers then filed several motions for acquittal based on technicalities. Those, too, were dismissed.

The *Akron Beacon Journal*, *Akron Press* and *Akron Evening Times* were filled with bold headlines about the Furnace Street gang. *Photo by Susan Gapinski Price.*

Jury selection began on May 7, 1918, and took three days to complete. The twelve-man panel consisted of E.R. Adam, secretary and treasurer of the Saalfield Publishing Company; Maurice Bettes, director of the Summit County Agricultural Society; J.B. Betz, a retired farmer from Norton; Charles Currie, former manager of Northern Ohio Traction & Light; Van Everett Emmons, an Akron real estate man; Otto N. Harter, president of Akron Pure Milk Company; Floyd W. Hoover, a Goodrich rubber worker; George C. Jackson, a commercial printer and former Akron council president; E.J. Larrick, district manager for Northwestern Mutual Life Insurance; Richard P. Mason, a Goodrich rubber worker; Bert T. Secrest, former secretary of Summit County Bank; and Levi Smith, a carpenter from Copley Township.

As was customary at the time, their names and addresses were published in daily newspapers without fear of reprisal or concern of intimidation. The men elected Currie as foreman and then spent the morning of Friday, May 10, walking along Main, Exchange, High and Broadway, surveying the district where Gethin Richards met his demise. Unlike the previous case,

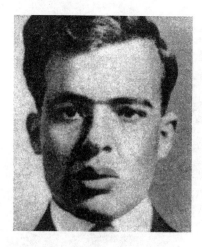

Frank Mazzano declined to testify at his own trial in Summit County. The jury deliberated only forty minutes. *Courtesy of Akron Police Museum.*

Judge Fritch ruled that Borgia's jurors should not read any newspaper accounts of the trial, but he again declined to sequester them in a hotel.

Escorted by Sheriff Jim Corey, a handcuffed Borgia lumbered into the courthouse from the jail tunnel and was as impeccably dressed as ever in a gray suit, rose-striped silk shirt, floral tie, gray socks and black shoes. In opening statements before a packed house, Prosecutor Cletus Roetzel outlined the tragic circumstances of the patrolman's slaying, while defense attorney A.E. Bernsteen told jurors that he would prove Borgia did not "abet or procure another" to commit homicide.

When Roetzel called his first witness to testify, it was like a bolt of lightning hit the defense table. Convicted murderer Frank Mazzano, the protégé of the Furnace Street gangster, casually walked past the open-jawed defendant and took a seat on the stand. Mazzano, who barely made a peep during his own trial, was about to sing like a canary. As Roetzel later explained:

> *Mazzano summoned me to the county jail the day after his conviction and told me he wanted to go on the stand and tell the whole truth. I told him I could promise him nothing and that if he confessed he would be doing so upon his own responsibility. He insisted and said that he had killed Richards, that the jury's verdict was just, that he knew he must die in the electric chair for his crime, and that he hoped for no reward for telling the truth…and that he wanted to relieve his mind of the awful weight of the crime he was carrying.*

Borgia tried to make eye contact with Mazzano, but the kid wouldn't look his way. Through the aid of interpreter Tony Jordan, Mazzano told the prosecution that Borgia had tricked him into not testifying in the first trial. Now condemned to execution, he had nothing to lose. "He told me not to tell anything," Mazzano testified. "That it would be better for me. The night before I was going to go on the witness stand in my own case, Rosario told me not to go and that they wouldn't send me to the electric chair. So I

didn't testify. He told me, too, not to testify against him and he would get me lawyers to appeal my case."

As Borgia grew visibly agitated at the defense table, Mazzano spilled the beans. He explained how he shot Mansfield white slaver Carlo Bocaro at Borgia's command because the Akron gang leader didn't like him. He noted that Borgia also "had it in for" Sicilian rival Frank Bellini, the original target on the night Richards was shot. "Rosario wanted Bellini killed because they were bad friends," Mazzano testified. The gang was considering hunting down Bellini at his North Howard Street home in the middle of the night early March 12 when the officer got in the way.

In a matter-of-fact manner that chilled listeners, Mazzano described the cop's slaying as nonchalantly as if he were describing what he had for breakfast that morning. He, Borgia and Paul Chiavaro had just turned the corner from Exchange Street to Main Street when the patrolman surprised them at Kaiser Alley, he said:

> There the policeman stopped us. He called "Hands up." He had a mace in his hands. First, Richards started to search Borgia. Borgia caught Richards by the arm and twisted it behind the policeman's back. Borgia then called to me, "Shoot him. If he finds the gun on us, we will all go to the electric chair."
> Then I shot. The first two shots didn't hit the policeman. One of them almost hit Rosario in the head. He yelled at me, "What's the matter with you? Can't you shoot straight? Are you trying to shoot me?"
> Chiavaro said "Go ahead and shoot. I'm watching. No one is looking."
> Rosario had told Chiavaro to "Stand watch." Then I took my gun in both hands and I shot Richards and hit him. Borgia left go of him then.

The prosecutor introduced as evidence the mangled .38-caliber revolver that had been found along the streetcar tracks near the scene of the deadly shooting. "Did you ever have that gun in your possession?" Roetzel said.

"Yes, that is the gun Rosario gave me," Mazzano replied. "That is the gun I shot the officer with."

With Mazzano on the stand, the sensationalistic *Akron Press* had a field day in describing Borgia's reactions to the squealing backstabber. The newspaper painted a grotesque picture of a guilty man cornered like a rat: "His skin, usually an olive hue, was pasty. His face was a bluish-gray, resembling the color of wood ashes. His lips, dry and parched, were drawn back from his teeth in a snarl. His eyes narrowed to mere slits and his fingers twitched nervously."

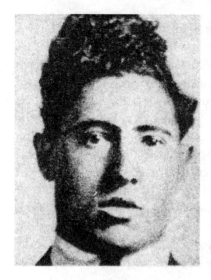

Gang leader Rosario Borgia didn't fire a single shot against Akron police and fully expected to be cleared of murder charges. *Courtesy of Akron Police Museum.*

Borgia wore a frozen smile as his rival Bellini took the stand to corroborate Mazzano's story. The businessman said that he and Borgia had feuded for years, and he didn't buy it when the gangster called him to the Furnace Street pool hall with a peace offering. "It is lucky for Bellini that the gang didn't find him the night Richards was murdered or he would not have been here to testify in this case," Assistant Prosecutor Charles P. Kennedy told the packed courtroom.

Although there were dozens of witnesses yet to testify, defense attorneys A.E. Bernsteen and Stephen C. Miller knew they were already in trouble. They tried poking holes in the testimony of Mazzano, Bellini and other witnesses, questioning the accuracy of their memories, but the testifiers stuck to their stories. The defense had no choice but to put Borgia on the stand and hope that the jurors believed him.

On May 16, Borgia took the stand before a hushed courtroom. He said it was true that he carried a gun, but he said it was because he feared that Bellini would try to kill him. He admitted that he was with Mazzano and Chiavaro on the night that Richards was gunned down, but he testified that he parted company with them before the shooting. Prosecutor Roetzel pounced on the alibi like a hungry cat on a fat mouse. In a heated exchange, the two men duked it out in court.

> Borgia: *"When we went around the corner on Main Street, we walked a little ways and then Frank Mazzano stopped. 'Well,' Mazzano said, 'I live south. I must leave you here and go back. I must go to bed.' So I shook hands with him and started north."*
>
> Roetzel: *"And where was Paul?"*
>
> Borgia: *"I think he was with Mazzano saying good night. I didn't look. And then I…"*
>
> Roetzel: *"Although you knew Paul lived on Furnace Street and would walk north, too, you walked off without him?"*

Borgia: "Yes. When I got almost to the alley, a man came out and went past me."

Roetzel "A policeman?"

Borgia: "I didn't know. I couldn't see. He went too fast and then in a minute I heard shots. Bang! Bang! Bang! And then I threw my gun into the doorway and walked back to the Buchtel and went to bed."

Roetzel: "You didn't see the shooting then?"

Borgia: "No, I never turned around. I didn't know who was shot. I was afraid they might catch me with a gun on me and think I did it, so I threw my gun away."

Escorted back to jail after testifying, Borgia exploded in rage. "I was there when Frank Mazzano shot the policeman, but I didn't have anything to do with it," he told New York detective Michael Fiaschetti. "The whole thing is a frame-up on me by those Sicilians. I'm a Calabrian. If I'm convicted and sent to my death, it will be because those crooks were able to make the jury believe their lies."

During closing arguments, Assistant Prosecutor Kennedy told jurors, "If you decide that Rosario Borgia is guilty of first-degree murder, then you must vote for that verdict regardless of consequences. For if Borgia is found guilty of a crime which may cause him to lose his life, it will not be the jury, the prosecutor, the judge or the state which has passed that sentence upon him. It is his own deeds which will have condemned him."

Defense attorney Steve Miller countered that Borgia was merely in the wrong place at the wrong time. "We are not here to rob the electric chair and we are not here to kidnap anyone from the penitentiary," he told jurors. "We are not here to protect anyone guilty of the murder of Richards. The state has had its vengeance in the conviction of Mazzano. I could talk a week in behalf of Borgia because I believe he is innocent of the crime charged."

The jury began deliberations at 4:25 p.m. on Friday and broke for dinner at 7:30 p.m. before reconvening at 9:00 p.m. Borgia went back to his cell, put on his nightclothes and went to bed, thinking no news was good news. Sheriff Corey arrived at Borgia's cell at 10:30 p.m. and told him, "The jury has agreed on a verdict."

As the boss was led away, Mazzano mused in his cell, "Here's where Rosie gets his."

The courtroom was filling back up when Borgia arrived. Defense attorney A.E. Bernsteen had gone home for the night, leaving Miller in charge as assistant.

"Have you reached a conclusion?" Judge Fritch asked the jury.

"We have," foreman Charles Currie said.

Borgia scanned the faces of the jury for a hint as Currie read the verdict at 11:10 p.m.: "We, the jury in this case, being duly impaneled and sworn to well and truly try[,] and true deliverance make between the state of Ohio and the prisoner at the bar, Russell Berg alias Rosario Borgia, do find that the prisoner at the bar is guilty of murder in the first degree as charged in the indictment, and thereupon said defendant is ordered into the custody of the sheriff to await sentence."

"What does it mean?" Borgia asked his attorney.

"Death chair," Miller replied.

THE GANG'S ALL HERE

Rosario Borgia, Akron underworld czar, sputtered in disbelief after the verdict. "That was a hell of a jury!" he cried while being led back to his cell. "And that lawyer didn't try to defend me." Thinking it over, he muttered, "I suppose those Italians, those Sicilians, are satisfied now. They got me where they want me." Borgia's wife, Filomena, who hadn't visited the jail in ten days, sent a fruit basket to her husband on the day after he was convicted. "To hell with this stuff," he told a deputy. "Tell my wife to come to the jail to see me." When she arrived, the couple quarreled. "Take me out of here immediately," she told a jailer.

After a day to calm down, Borgia began to regain his swagger. "Why should I be afraid if I have lost the case?" he told a jailer. "I'll get a new trial. I got lots of money and I can get more." His lawyers filed a motion for a new trial, complaining, among other things, that the case should have been heard in a different county and that jurors should have been sequestered. Judge Ervin D. Fritch swatted away the motion.

Only a handful of spectators attended the hearing on Saturday, May 25, 1918, where Fritch sentenced Borgia to die in the electric chair. Asked if he wanted to make a statement for the record, Borgia merely sulked, "I have nothing to say." He returned to his cell to await the trip to the Ohio Penitentiary in Columbus.

Later that day, Akron's Italians celebrated the third anniversary of their native country's entry into the Great War. Businesses closed early so everyone could attend a grand parade featuring musicians, floats, banners

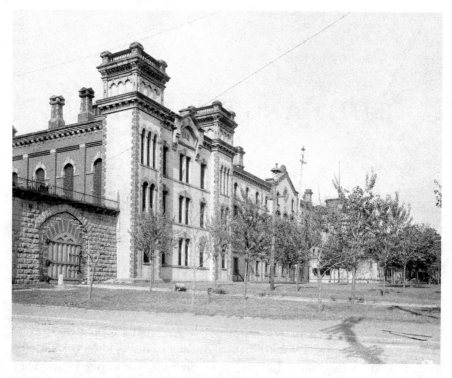

Following the murder trials in Akron, the Furnace Street gang was sentenced to the Ohio Penitentiary in Columbus. *Courtesy of Library of Congress.*

and a procession of two thousand Italian Americans. They marched from North Howard Street to Exchange Street and back, passing the county jail, where Borgia no doubt was still muttering.

With Borgia's conviction, public interest waned in the Furnace Street gang, but there were still four more trials scheduled that summer. Next up for Judge Fritch was Pasquale Biondo, charged in the January 10 murder of Patrolman Edward Costigan. Although Biondo had signed a confession, he claimed he only did it because New York detective Michael Fiaschetti had tricked him into believing he'd get a lighter sentence.

The court appointed Seney A. Decker and Carl Myers to serve as Biondo's defense. "While I do not care for the task which has been assigned to me and did not solicit it, as an officer of the court, I feel it my duty to do the utmost for the defendant," Decker announced. "He is entitled to a fair and impartial trial under the rules of the evidence." However, in his opening statement June 13, Decker admitted that he and Myers were not familiar with the case but hoped to prove that the crime was not "a free act of a free agent."

Prosecutor Cletus Roetzel introduced Biondo's confession of killing the "Red Policeman" for $150 under Borgia's command. "You kill him or I'll kill you," Biondo quoted Borgia as saying. The state questioned dozens of witnesses, but Biondo's own words probably were sufficient for a conviction during the climate of the time. As Assistant Prosecutor Charles P. Kennedy told jurors in his closing argument:

> *If you let a man who has committed a crime like this one go unpunished, if you give a recommendation of mercy to a man who for $150 crept up silently behind a man whose very name he did not know and shot him down like a dog, a man who had done him no harm, then I say to you that you will have the thieves, thugs and murderers flocking into Akron as a fertile field for their crimes.*

The trial wrapped up in five days, and the jury deliberated only seventeen minutes before reaching a verdict. Biondo was found guilty of murder and sentenced to die in the electric chair. "I don't care," he told a jailer, adding facetiously, "I should worry." Oh, but he did care. On July 4, the convicted killer tried to escape from the county jail.

He and three other inmates overpowered Deputy John W. McCaslin in the shower room, and Biondo seized the officer's gun and shot William F. Lowe, a trusty, in the abdomen when he tried to intervene. After a frantic search, Biondo couldn't find the keys, though, and surrendered when Deputy Scott Ingerton pointed a gun at him and ordered him to surrender. Fortunately, the bullet missed Lowe's stomach and liver, and he survived the shooting. Biondo was thrown back into his cell to await the trip to Columbus.

Paul Chiavaro was the next gang member to be tried before Judge Fritch. Detective Harry Welch always suspected that Chiavaro was the killer of Guy Norris, the first victim of the gangland war, but he could never pin it on him. Instead, Chiavaro was charged in the March murder of Gethin Richards, even though the gangster had only served as a lookout.

In the opening statement on June 28, defense attorney Stephen C. Miller contended that Chiavaro was only a spectator that deadly night and didn't even belong to the gang. Miller audaciously claimed that his client had merely gone for a late-night stroll with Borgia and the others after meeting them at the Furnace Street pool hall owned by Joe Congena.

Prosecutor Roetzel painted a grimmer picture, noting that Chiavaro was a hardboiled henchman who liked to use dum-dum bullets to inflict more damage on his victims, and he coated the bullets with oil of garlic

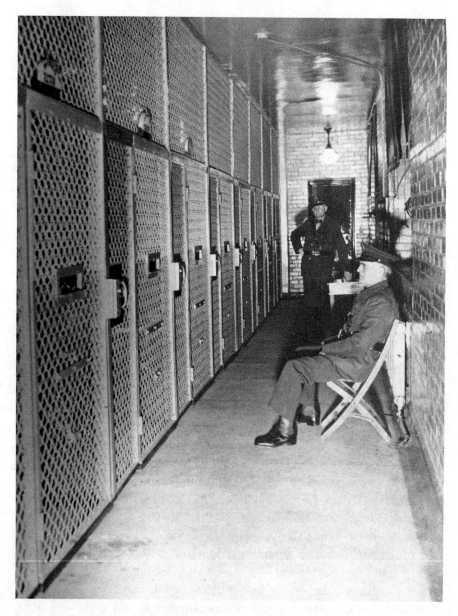

Prison guards keep close watch on the barred cells of death row inmates at the Ohio Penitentiary in Columbus. *From the* Akron Beacon Journal.

to deaden the nerves and blister the skin. In other words, the guy wasn't exactly a choirboy.

Convicted killers Borgia and Frank Mazzano were called back to the stand to testify, and they largely repeated their statements from the earlier trials. Chiavaro, who only spoke broken English, took the stand on July 3 and got confused as Roetzel read back the gangster's confession from earlier that year. When asked if those were his words, Chiavaro said, "I don't know if I said it or not." When Roetzel noted that Chiavaro had denied any involvement in the shooting after being arrested, the gangster said, "I was excited. I was excited. My head was mixed. I didn't know what I was saying."

In closing arguments, prosecutors told jurors that even though Chiavaro served as a lookout, he was just as guilty of murder as Mazzano, the triggerman, and Borgia, the man who ordered the killing, because he had aided and abetted the death of Patrolman Richards. Jurors began deliberations at 4:30 p.m. on Friday afternoon and returned a verdict at 11:00 p.m. that night: guilty without recommendation of mercy. Sentenced to death at a July 13 hearing, Chiavaro could only grouse, "I am not to blame."

After the Chiavaro trial, Prosecutor Cletus Roetzel got ready for military training at Camp Taylor and turned over the reins to assistants Charles P. Kennedy and William A. Spencer. Meanwhile, Judge William J. Ahern took over for Judge Fritch. Perhaps that's why the outcomes were so different—or maybe it was because of the defense lawyers.

Lorenzo Biondo, alias James Palmieri and Jimmy the Bulldog, went on trial August 7 in the January slaying of Patrolman Joe Hunt. He hired Cleveland attorney Benjamin D. Nicola, age thirty-nine, as his defense lawyer, and it was an inspired choice. Nicola was born in Italy in 1879, immigrated to the United States at age nine and grew up in the Tuscarawas County town of Uhrichsville, where his family operated a general store and butcher shop.

After high school, Nicola studied law at Ohio State University, passed the bar exam in 1904 and put up a shingle in Cleveland, where he became the first Italian American lawyer in the city's history. Unlike other attorneys for the Furnace Street gang, Nicola understood the Italian culture and spoke the language.

His plan of attack in the Biondo trial was to discredit the confession that his client had given to New York detective Michael Fiaschetti after being captured in Brooklyn. In his opening statement, Nicola reminded jurors to keep their minds open because a man was presumed innocent until proven guilty.

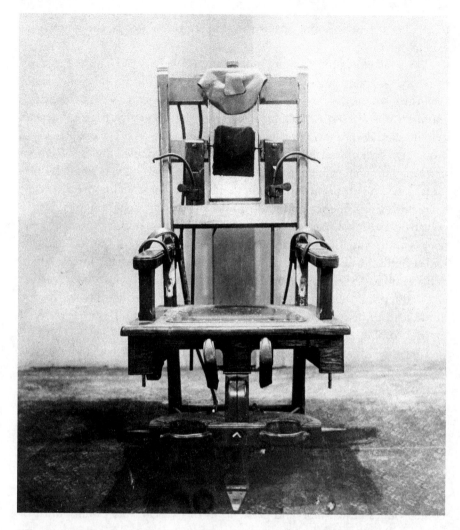

The electric chair awaits the Akron police killers at the Ohio Penitentiary. *From the* Akron Beacon Journal.

The defense began to hammer away at Fiaschetti, the cosmopolitan cop described by co-counsel Henry Hagelbarger as "the dressy detective," "the handy Andy" and "the courthouse favorite."

Anthony Manfriedo, who served as the lookout on the night that Costigan and Hunt were slain, took the stand to back up the defense's contention that he and Lorenzo Biondo signed confessions because Fiaschetti promised them that they would escape the electric chair if they did. "They don't want you, they want Borgia," Manfriedo said the detective told them.

In rebuttal, Kennedy called Fiaschetti to testify about his tactics with Biondo. "All I told him before he made the confession was that Manfriedo had made a true statement and that Mazzano had identified him as the man and that it would be better for him to tell the truth," he said.

With the war in Europe dominating headlines, Akron residents showed little interest in the Biondo case. The sweltering courtroom didn't have air conditioning and sat mostly empty as summer temperatures soared to a record-breaking 104 degrees.

In closing, Kennedy told jurors that Biondo was nothing but a coward for shooting Hunt in the back: "And what a price for a human life. A man that he did not know and against whom he had no grievance. A paltry $100, which this man Biondo tries now to tell you was forced upon him by Borgia."

But Nicola told jurors that Biondo only acted "under the power and fear" of Borgia. If he hadn't shot the officer, Biondo would have been killed himself, Nicola said. He beseeched the juror for leniency.

The jury began deliberating at 3:45 p.m. on Tuesday, August 14, and wrestled with the case for eighteen hours before going home for the night without a verdict. According to courtroom scuttlebutt, the jury initially voted eleven to one for the death penalty but couldn't get the twelfth man to agree. H.T. Wallace, a Republican candidate for Ohio representative, served as foreman.

"The jury made an attempt to communicate with Judge Ahern Wednesday morning by a written statement," the *Beacon Journal* reported. "Ahern destroyed the statement unread and sent word to the jury by the bailiff that such a procedure was not allowed and for them to make no attempt to communicate with him until they reached a conclusion."

Deliberations resumed, and rumors circulated of a deadlock before the panel announced it had finally reached a verdict about twenty-four hours after the discussions began.

"Have you reached a conclusion?" Judge Ahern asked the jury.

"We have," Wallace said.

The jury found Biondo guilty of first-degree murder with a recommendation of mercy. A confused Biondo looked to Nicola for an explanation and was visibly relieved when the attorney explained that the verdict meant life in prison instead of the electric chair. At the sentencing hearing on August 24, Judge Ahern added a clause to the life term. Every February at the Ohio Penitentiary, Biondo would have to spend four days in solitary confinement to remind him of the four days that Patrolman Hunt lingered before dying.

Anthony Manfriedo's case was resolved in record time. On Friday, August 16, 1918, the confessed lookout and all-around lackey avoided a jury trial by pleading guilty to murder as an accessory and throwing himself on the mercy of the court. Judge Fritch sentenced Manfriedo to life imprisonment on August 20 and sentenced him immediately to the Ohio Penitentiary to be reunited with his old gang.

DEATH HOUSE

As a matter of course, defense attorneys appealed the sentences of Rosario Borgia, Frank Mazzano, Pasquale Biondo and Paul Chiavaro as they sat on death row in Columbus. Appellate judges began taking up the cases in September 1918 and postponed three of the four executions until early 1919. An unbelievable mistake caught the justice system by surprise.

Biondo's execution was scheduled for October 4, 1918, at the Ohio Penitentiary. As the date drew closer, court-appointed attorney Seney A. Decker of Barberton worked on the paperwork for a stay of execution. The board of appeals in Cleveland agreed in early September to grant a reprieve, but Decker neglected to prepare an entry in the court journal as required.

Notified of the oversight, Decker had a justice of the peace deliver the proper documents to Cleveland early Tuesday, October 1, but the appellate judges were away at a Liberty Loan event, so a clerk promised to have the judges sign the papers and mail them to Barberton in time to halt the execution.

The twenty-seven-year-old Biondo waited for a call that didn't arrive. He spent his final hours praying with Reverend Francis Louis Kelly, age sixty-seven, a Roman Catholic prison chaplain, before they walked together to the death chamber. Passing Borgia's cell, Biondo shouted, "I'll see you in hell!"

Afterward, Biondo showed no emotion as he marched toward the electric chair. He prayed with the priest and kissed a crucifix before being blindfolded and strapped into the chair. Patrolman Edward Costigan's killer declined to deliver any last words before the electric current passed through his body

Pasquale Biondo was executed on October 4, 1918, for the murder of Patrolman Ed Costigan. The execution could have been delayed, but the paperwork arrived late in the mail. *Courtesy of Ohio History Connection (State Archives Series 1000 AV).*

shortly after midnight. After thirty seconds, Dr. O.M. Kramer, prison physician, pronounced the gangster dead.

About nine hours later, the letter granting a stay of execution arrived in the mail at Decker's office in Barberton. As the defense attorney told the *Beacon Journal*:

> *It is a very unfortunate state of affairs, but it is simply the result of circumstances over which no one had any control, and while no one knows what the ultimate outcome would have been had we the chance to argue the case again, I regret exceedingly that the execution was not stayed because there were several important questions of law which should have been passed by the court of appeals.*

As Judge Charles R. Grant concluded at the appeals court, "It is a regrettable occurrence and should be a lesson to attorneys in such criminal procedures in the future."

When news broke that the Allies had signed an armistice with Germany to end the Great War in Europe, giddy Akron residents celebrated with a massive parade on November 11, 1918. Hundreds of thousands of residents poured into the streets in a cathartic overflow of joy. Church bells rang, factory whistles blew and motorists honked horns. The war was over! The troops were coming home! The following day, Sheriff Jim Corey escorted

Borgia and Mazzano to Akron to attend a quiet appeal of their death sentences. The former friends were handcuffed together and led into the Summit County Courthouse.

Defense attorneys said the men deserved another trial for multiple reasons, including prosecutorial misconduct, the trial judge's errors and a lack of sufficient evidence. The appellate court refused. "Mazzano's was a dastardly crime committed in response to the instructions of the padrone," Judge Grant said. "The case was tried with patience and exceptional ability, and this court finds no error."

Regarding Borgia's appeal, Grant stated, "You murdered a man who had never offended you and made his children orphans. You made the mistake in assuming that a practice en vogue in the mountains of Sicily could be followed here."

Borgia didn't have time to explain that he was Calabrian, not Sicilian. The men's execution date was affirmed for February 21, 1919, in Columbus. Partners in crime, they would die on the same night. Borgia and Mazzano were escorted through the tunnel to the county jail. "We only got to die once, so we should worry!" Borgia shrugged to jailer J. Henry Bair. "Goodbye. We may not see you again."

After the Ohio Supreme Court denied a final appeal on January 21, the Ohio Parole Board refused a commutation and Governor James M. Cox declined to interfere, the gangsters' fate was sealed. The condemned men were kept in solitary confinement at the death house and weren't allowed visitors.

"Oh, Rosario, my man, my Rosario!" Filomena Borgia wailed on February 20 outside the gray stone walls of the Ohio Penitentiary. "Oh, what a shame to kill you, my man, my Rosario! Rosario, they are going to kill you, to take you from me in a few minutes. I will kill myself, Rosario, my man!"

Inside the death house, things were proceeding as scheduled. A prison barber shaved a circle on Borgia's and Mazzano's heads and shaved their right calves for the placement of the electrodes. The condemned men somehow had rekindled their friendship on death row. Mazzano forgave Borgia for leading him down a criminal path as an impressionable youngster. Borgia tried to overlook the fact that Mazzano had ratted him out in court. If only they had been able to tame their murderous impulses, they could have made a black market fortune as bootleggers during Prohibition, which was ratified into law that same month.

On the eve of the execution, Borgia and Mazzano spent two hours talking with Sheriff Pat Hutchinson, who took office in January, and Akron cops Ed

and Will McDonnell. The convicts had ordered a last meal of fried chicken and ice cream, but they barely had a bite.

"The ice cream melted and ran over the dish while we stood there," Will McDonnell said. "It reminded me of the sand in an hourglass as it indicated how quickly death was approaching for the two men."

Borgia and Mazzano made a last-hour request for former sheriff Corey to visit them. He was summoned from the death chamber, where he was preparing to witness the executions with W.L. Norris, the father of Guy Norris, the first cop killed in the gangland war.

"Hello, Jim," Borgia said upon seeing Corey. "Frank wants to make a confession."

"I don't want to die with a lie on my lips," Mazzano told Corey. "When I testified that Borgia held the arms of [Gethin] Richards and bent it behind his back, that was a lie. Borgia did not do that. I don't want to die with that lie on my lips. The rest of it was true."

Mazzano, age nineteen, was the first to leave. He prayed with Father Kelly and held a silver crucifix as he was led to the electric chair. When he saw his old jailers Carl Repp and J. Henry Bair among the one hundred witnesses in the observation room of the death chamber, he cried out, "Tell my friends in Akron I died game."

Attendants strapped Mazzano's chest, arms and feet to the chair and applied electrodes to his right leg and head. Asked if he had any final words, a blindfolded Mazzano shook his head and began a quiet prayer. In a gruesome account, the *Beacon Journal* described the young gangster's death:

> *Dr. Kramer stepped off the platform, into the booth at the side of the room and there pressed a button which gave the signal in the dynamo room. Three guards there pulled three levers, two of them being blanks, the third sending the current into Mazzano. It was just 12:05 when a sound as of a lever striking metal was heard, a low whining hum followed and Mazzano's body strained against the straps, and then relaxed. Once again, after a pause, the current was turned on, and for the third time and at the last contact, the electrode on the leg turned into a white flame and a curl of smoke went up where the flesh and hair burned.*

Dr. Kramer pronounced the inmate dead, undertakers removed Mazzano's body for burial at Mount Calvary Cemetery in Columbus and prison guards immediately prepared the death room for the next execution.

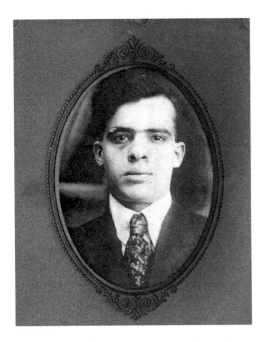

Frank Mazzano was executed on February 21, 1919, for the murder of Patrolman Gethin Richards. "Tell my friends in Akron that I died game," he cried out in the death chamber. *Courtesy of Ohio History Connection (State Archives Series 1000 AV).*

Borgia, age twenty-four, who had converted to the Presbyterian faith in prison, walked with Reverend Thomas O. Reed toward the electric chair but began to crack as he neared the double doors to the death chamber. Two guards had to support his bulky frame while Borgia stepped warily onto the platform and stared wide-eyed at the lethal apparatuses in the room. Attendants strapped him to the chair, attached electrodes to his body and placed a black veil over his head.

Asked if he had any final words, Borgia replied in broken English, "I want to say an innocent man dies. Mazzano lied about me. I don't think it right for me to die. I am innocent."

"Is that all you have to say?" Kramer asked.

"That's all I have to say," Borgia replied.

Moments later, the hum of electricity filled the room. Borgia's body convulsed, relaxed and convulsed. After two contacts, Borgia was declared dead, and his body was removed from the room. Witnesses somberly filed out of the observation room to leave the prison.

The *Akron Press*, as sensational as ever, described a grisly postscript to the public execution. After Borgia's body was carried away, a man identified only as "prison undertaker Shaw" later claimed that the gangster revived. "His heart was thumping away like hell," Shaw said. The attendants quietly returned Borgia to the empty room without any witnesses and turned on the

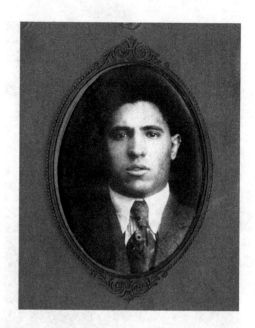

Gang leader Rosario Borgia was electrocuted on February 21, 1919, for the murder of Patrolman Gethin Richards. He proclaimed his innocence until the end. *Courtesy of Ohio History Connection (State Archives Series 1000 AV).*

juice again. "They were so excited on discovering he was still alive they gave him a third shock that burnt the hell out of him."

Borgia's brother Dominick, who lived in Rochester, New York, claimed the body and had it transported to his hometown, where the gangster was buried at Riverside Cemetery. Newly widowed Filomena Borgia soon discovered that "her man Rosario" had cut her out of his will and bequeathed his entire estate to his brother.

Three members of the Furnace Street gang had been executed. One was waiting on death row. Two others were serving life sentences. Things were beginning to get back to normal in Akron.

Two weeks later, three more cops were shot.

ECHO OF GUNFIRE

T hieves were stealing chickens along Hickory Street, and neighbors were angry. Michael Iamme, the latest victim, heard a noisy disturbance around 2:00 a.m. on Sunday, March 9, 1919, in his Tarbell Street backyard and stepped out to investigate, but his wife, Julia, urged him to call the police. Officer John Goodenberger quickly arrived at the scene and discovered that someone had cut the locks and hinges off Iamme's coop and stolen sixteen chickens from the property along the Baltimore & Ohio Railroad tracks.

After daybreak, Iamme warned his neighbor Mary Kleinmetz about the crime and urged her to be careful. She was emptying a pail of water in her backyard around 8:30 a.m. when she noticed strangers approaching. "I saw these three men come up the track, and when they got opposite the Iammes' coop, they stopped, looked at it and smiled, and then walked on towards the west," she later testified.

Kleinmetz told her sister, Amelia Nuss, who lived next door, and she called police to report, "There are three suspicious-looking men on the railroad crossing on Hickory right now."

Patrolmen George Werne, Will McDonnell and Stephen McGowan pulled up in a squad car, spotted the men at Hickory and Ravine Street and went to question them. Italian Americans Panfilio "Andy" Damico, his brother Vincenzo Damico and Pietro "Peter" Cafarelli stopped to face the plainclothes officers.

"You are under arrest," Werne told the men, flashing a badge.

McDonnell was the first to see one of the suspects raise a revolver. "Shoot! Quick!" the officer warned his colleagues. In an unexpected, chaotic, life-and-death struggle, the cops grappled furiously with the men as a fusillade of shots shattered the Sunday morning calm.

Four bullets struck McDonnell, piercing his jaw, back, left shoulder and leg. McGowan was shot in the back, a slug puncturing his right lung. Another bullet hit Werne in the neck, severing his jugular vein. At least two of the officers managed to fire off shots before collapsing to the ground.

Panfilio Damico, age thirty, a rubber worker at Goodyear, made a mad scramble down the ravine and plunged into the Little Cuyahoga River to swim across. His brother Vincenzo, age twenty-four, a laborer, followed the same frenzied path and also jumped into the strong current. Cafarelli, age twenty-nine, who owned the nearby grocery at 115 North Maple Street, ran down the embankment in a panic but reconsidered his actions and climbed back up to the tracks just as other officers arrived.

McDonnell, McGowan and Werne were rushed to Akron City Hospital. The patrolmen's wives were notified about the shootings before or during church services at St. Mary, St. Vincent and St. Bernard.

Werne, age thirty-two, was pronounced dead on arrival, the fifth Akron cop to be slain in fifteen months. He left behind a widow, Anna, age twenty-nine, and three children: Marie, eight; Richard, four; and Pearl, six months old.

"Patrolman Werne was slain by a single bullet," coroner Carl Kent announced after an autopsy. "It came from a 32-caliber automatic revolver. The bullet entered the right side of the neck and severed the spinal column of the fourth cervical rib. I am of the opinion that Werne met with instant death."

Lieutenant Frank McAllister; Detective Charles Doerler; Detective Patsy Pappano; Patrolmen Jacob Bollinger, Joe Petras and Eugene Murray; and Sheriff Pat Hutchinson rushed to Hickory Street after hearing reports of gunfire. Motorcycle cop Walter Horn saw Vincenzo Damico running near the river and fired a shot that struck his left arm. Bleeding and soaking wet, Damico broke into a cellar at 211 Mustill Street in an attempt to hide, but a neighbor alerted officers, and Horn, McAllister and Murray pulled him out at gunpoint. Police took Damico and Cafarelli to headquarters for questioning.

"I ought to give you what you deserve right here," said Detective Ed McDonnell, whose brother was fighting for his life. "I'm an officer and will let the law take its course."

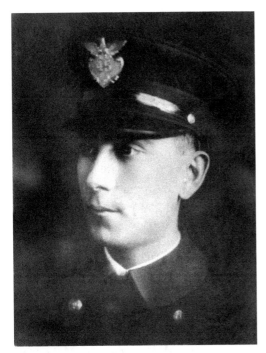
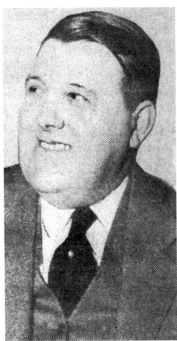

Left: Patrolman George Werne was shot to death on March 9, 1919, off Hickory Street near the railroad tracks while he and two other officers investigated the overnight theft of chickens from coops. *From the* Akron Beacon Journal.

Right: Edward McDonnell was promoted to chief detective and then captain before retiring in 1933. He died following appendix surgery. *From the* Akron Beacon Journal.

Arraigned in police court before Judge Lloyd S. Pardee on charges of first-degree murder, Cafarelli pleaded not guilty, but Damico refused to cooperate. Pardee entered a not guilty plea for him.

"I don't care," Damico said. "I don't care what you do with me."

Police took Damico and Cafarelli to City Hospital to see if the wounded officers could identify them. A bullet in his lung, Patrolman McGowan, age thirty-five, looked up from his bed when cops escorted Damico into the room. "I wished I had a gun," he said. "I'd shoot you right where you stood. That's the man who shot me."

At Will McDonnell's bedside, Cafarelli begged, "Please don't tell them I did any shooting."

"You rat," replied McDonnell, age thirty-eight. "You sneaking rat. You were there and did some of the shooting."

Police officers and armed posses searched the Hickory Street neighborhood for more than thirty hours but couldn't find the third suspect, Panfilio Damico. After he swam across the river, he vanished into thin air. Tips poured in after a $500 reward—dead or alive—was offered for the arrest of the five-foot-seven, 160-pound fugitive, but he never was captured. Authorities speculated that he escaped to Italy. Besides abandoning his brother, he deserted his wife, Margherita, who filed for divorce a year later and married another Italian.

Speculation immediately arose that the shootings were related to Rosario Borgia's Furnace Street gang. Investigators downplayed a connection, though, believing that the Damico brothers were petty thieves. There were unusual ties, however. The Hickory Street shootout was only a few blocks away from Furnace, and Patrolmen George Werne and Will McDonnell were the first Akron officers to arrest Borgia in 1916.

"Rosario Borgia had the right hunch," McDonnell said at the hospital. "Borgia told me when I saw him a few hours before his execution that I'd better watch out or someone would get me. I didn't think, however, that it would come so soon."

Initially given a slim chance for survival, McDonnell and McGowan recovered from their wounds and enjoyed long careers with the force.

The community rallied around Werne's grieving family. Akron rubber executives C.B. Raymond of Goodrich, C.W. Seiberling of Goodyear and William F. O'Neil of General pledged $250 apiece to pay off the mortgage on the Werne house. The *Akron Beacon Journal* established a fund that collected more than $3,300 in three weeks. The American-Italian League of Akron raised $200 for the widow and children.

"We deeply regret the crimes that some of our people have committed, and desire to make it known to the public that these people who have no regard for law and order do not represent the better class of Italians," said Akron banker Francis S. Massimino, league president. "We shall do all in our power to run down these fellows responsible for the disgraceful crimes committed."

On March 12, the first anniversary of the death of Gethin Richards, two dozen officers escorted Werne's casket from the family home on Marcy Street to St. Bernard Catholic Church to Holy Cross Cemetery. Pallbearers were Sergeants Edward Heiber, Edward Heffernan and Patrick Raleigh and Patrolmen Eugene Murray, Henry Bergdoll and John McMenamin. In his eulogy, Reverend Joseph M. Paulus noted, "Society must protect itself, law must be respected and obeyed and criminals must be punished."

Cafarelli and his wife, Anna, had four young children—Elizabeth, seven; Adeline, five; Fannie, three; and Dominic, six months—with a fifth, Grace, on the way. The family rented apartments at the grocery to the Damico brothers. A christening party for the infant Dominic was planned on the day that Werne was killed, and investigators theorized that Cafarelli and his tenants raided the coop to serve chicken at the reception. Cafarelli said that his wife bought chicken for the christening, but Patrolman Patsy Pappano reported finding a burlap bag with feathers inside, plus locks and hinges that may have come from the coop.

Cafarelli insisted that he didn't own a gun and never fired a shot. He maintained that he was a victim of circumstance and that Will McDonnell had confused him with gunman Panfilio Damico. The only reason he was on the tracks was that the Damico brothers were shaking him down for cash, he said. "I did not want to go out that morning," he said. "First they said to go and get some fresh air, and when I said I did not want to leave because the baby was sick, they said I had to go out, they forced me to go out."

He said he tried stopping twice, but the brothers pushed him along. Eventually, Panfilio turned to him and said, "You know the purpose we came down here for," Cafarelli said. The brothers took two checks for about fifty-five dollars and were just about to take the seventeen dollars in his pocket when the police walked up, he said.

Judge William J. Ahern presided over Vincenzo Damico's trial, which opened on May 22. Prosecutor Cletus G. Roetzel, back from military service, handled the state's case. Attorney Rolland Jones led the defense.

Jones argued that fugitive Panfilio, not Vincenzo, fired the fatal shots. Furthermore, he said Panfilio fired in self-defense, thinking the plainclothes officers were hobos intent on robbing them. "The three officers were brigands, assassins, by not showing their badges," Damico said. "I did not see any badges."

Jurors deliberated forty minutes May 26 before finding him guilty. Jailers found Damico weeping on the cell floor. "I kill

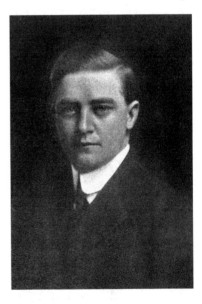

Judge William Ahern presided over the Peter Cafarelli and Vincenzo Damico cases. He died unexpectedly at age thirty-eight. *Author's collection.*

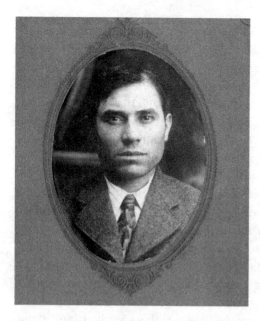

Paul Chiavaro was executed on July 24, 1919, for the murder of Patrolman Gethin Richards. He died with a smile on his lips. *Courtesy of Ohio History Connection (State Archives Series 1000 AV).*

nobody," he cried after being sentenced to death. He was taken June 2 to the death house, where Furnace Street gangster Paul Chiavaro, the prisoner in the next cell, greeted Damico in Italian.

The execution of Chiavaro on July 24, 1919, was almost an afterthought. Only seventeen witnesses were present as the thirty-one-year-old walked to the death chamber with Reverend Francis Louis Kelly. A serene Chiavaro prayed, kissed a crucifix and wore a faint smile as attendants strapped him to the electric chair.

"Have you anything to say before the sentence is executed?" Warden Preston E. Thomas asked.

"Nothing to say," Chiavaro said. Switches were thrown, electricity hummed and Chiavaro died at 12:09 a.m. with a smile on his lips.

Cleveland attorney Benjamin D. Nicola, who had filed several motions in an effort to spare his client, was heartbroken. "It is a mistake, I am sure, to put Chiavaro to death," he said. "I believe he is innocent."

The execution of Vincenzo Damico, age twenty-five, took place on March 31, 1920. The condemned man cried, "Mother Maria! Mother Maria!" as Father Kelly walked with him to the electric chair. The death house lights flickered at 12:06 a.m., and Damico's body was taken to Calvary Cemetery in Columbus. "Nineteen men have been electrocuted during my regime here, and it is the first time that a man met his end crying," Warden Thomas said.

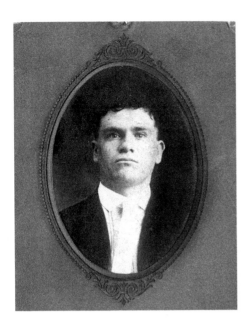

Vincenzo Damico was executed on March 31, 1920, for the murder of Patrolman George Werne. He cried while being led to the electric chair. *Courtesy of Ohio History Connection (State Archives Series 1000 AV).*

Maintaining his innocence, Pietro "Peter" Cafarelli fought tooth and nail. He was convicted of murder in a June 1919 trial and sentenced to death in October, but the appellate court rejected the verdict and ordered a new trial because the defense had not been allowed to examine a list of six potential jurors.

In the second trial, which began on February 26, 1920, defense attorney Joseph V. Zottarelli argued that Cafarelli had feared for his life when Vincenzo and Panfilio Damico demanded his cash after forcing him down the railroad tracks. He actually felt relieved to see the plainclothes officers, he said. "Cafarelli regarded the arrival of these three men as an intervention of Divine Providence, and he said fervently to himself and his God, 'My God, I thank thee for sending these men to save me,'" Zottarelli said.

On March 5, the jury convicted Cafarelli of first-degree murder with a recommendation of mercy, sparing him the electric chair. Judge Ahern sentenced him March 13 to life in prison. "All I have to say, your honor, is that I am innocent, and I am convinced that I can show my innocence yet," Cafarelli said.

For more than ten years, Cafarelli tried to clear his name at the Ohio Penitentiary. Prisoner 48462 was a model inmate—polite, pious, orderly and obedient—working as a skilled mechanic in the machine shop. During a 1939 interview, the forty-year-old convict told a *Beacon Journal* reporter, "Maybe you will say in your paper that it was not I who fired the shot, that

it was not I who carried the gun, but that it was Damico, and I have been many years here. I am old now."

At least three jurors reversed themselves and lobbied state officials for a pardon. Former prosecutor Cletus Roetzel wrote to two Ohio governors to urge Cafarelli's release, saying, "There is no doubt that Cafarelli is guilty as indicated by the evidence of the trial. I am convinced, however, that he did not fire the shot that killed Werne, and that he is not by nature criminally inclined."

Pietro "Peter" Cafarelli, age forty-one, enjoyed one last visit with his wife and five children on April 21, 1930. Three hours later, a savage fire swept through the Columbus penitentiary, killing 322 inmates. Rescue crews found Cafarelli's body in his locked cell. He was clutching a rosary when he died. "He was the best prisoner in the penitentiary," Warden Preston E. Thomas sobbed to a reporter.

EPILOGUE

Furnace Street cleaned up its act long ago. The formerly notorious neighborhood is home today to the Northside District, a cultural center of arts, dining, entertainment, shopping and recreation. The district's attractions in 2017 included Luigi's Restaurant, an Akron institution since 1949; Dante Boccuzzi Akron, an upscale restaurant owned by a famed Cleveland chef; Jilly's Music Room, a concert club and tapas bar; Zeber-Martell, an art gallery and studio; Rubber City Clothing, a popular shop for Akron streetwear and accessories; Northside Lofts, luxurious living on the edge of downtown; and the Courtyard by Marriott, a hotel with a Prohibition-themed cocktail bar called the Northside Speakeasy.

Traveling farther east on Furnace Street, motorists can scarcely imagine what it was like a century ago. Most of the old buildings have been demolished, leaving vacant lots and overgrown woods. It's like a giant broom swept away the original homes, saloons, brothels, pool halls, restaurants, coffeehouses, hotels, cigar stores, barbershops, tailors shops and confectioneries.

A little brick building topped with a big white cross is a reminder of yesteryear. The Furnace Street Mission chapel, which was constructed in 1962, replaced the original building where Reverend Bill Denton (1895–1982) established the "Brightest Spot in the Underworld" in the late 1920s. Denton set up a soup kitchen, provided clothes for the needy, operated a halfway house and preached the Gospel at the mission, which originally was located at 121 Furnace Street in Joe Congena's former pool hall, the hangout of Rosario Borgia.

"I can remember as a kid being fascinated by a trap door in the back of the building floor that led to a meeting room, which was where the murders were planned," said Reverend Bob Denton, Bill's son and successor in the ministry. "Always wanted to explore that but Dad put the quietus to that."

Captain Al "Fuzzy" Monzo (1915–2012), an Akron cop for thirty-six years, once explained to the younger Denton how the original building was moved to 140 Furnace. "He was a young kid who lived down here when the neighborhood was primarily Italian," Denton said. "My dad enlisted a bunch of the kids—including him—to pick up the building, put it on poles and roll it across the street to its final location—about where our drive is on the current property."

Irony of ironies, the murderous Furnace Street gang's old hideout became a place to save souls. The mission opened a halfway house for ex-convicts and established the nationally acclaimed Victim Assistance Program. Borgia definitely wouldn't recognize the neighborhood today.

Giacamo Ripellino, better known as Frank Bellini, happily took over Borgia's criminal enterprises and became one of the region's most powerful gangsters over the next decade during Prohibition. Police connected him

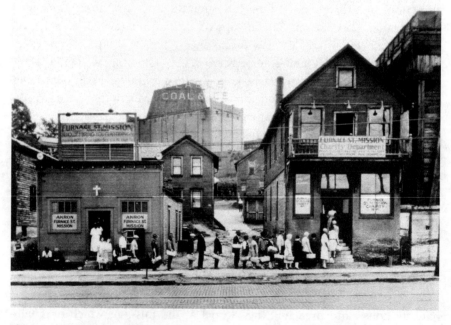

Needy people form a bread line outside Reverend Bill Denton's Furnace Street Mission in the 1930s. The building at left once stood across the street and served as the lair of the Furnace Street gang. *Courtesy of Furnace Street Mission.*

with bootlegging, prostitution and murder, but he never was convicted of any serious crimes. In fact, he was known for his generosity, donating money to poor Italian families. Bellini outwitted his enemies for years, but the fifty-two-year-old let down his guard on June 27, 1929. He and four friends were sitting outside his store at 106 North Howard Street when a large touring car pulled up, curtains parted on the windows, and three shotgun blasts struck Bellini. The car sped away and the gunmen escaped, never to be found. Police suspected that an old friend of Borgia's was settling a score. Doctors amputated Bellini's legs at St. Thomas Hospital, and he died of an infection June 28. More than three hundred people attended the rites at St. Vincent Church, which one newspaper described as "Akron's first intimate glimpse of a gangland funeral." Bellini was laid to rest in a bronze casket at Holy Cross Cemetery.

Like so many of his customers, pool hall operator Joe Congena, age thirty-seven, met a violent death. Boarding at the home of Rosario and Rose Cusamano at 118 Furnace, he threatened to blackmail his nineteen-year-old landlady over allegations of marital infidelity with another tenant, Joe Catanio, age thirty-nine. On August 17, 1921, she lured Congena into the cellar, where Catanio killed him with four blows from a hatchet. Rose Cusamano initially alleged self-defense, but she and Catanio were convicted of first-degree murder.

Furnace Street gang member Salvatore Bambolo joined the U.S. Army, got married in 1920 and stopped hanging out with the wrong crowd. He moved to California, where he operated a fruit and nut business before retiring in 1970. He was eighty-four years old when he died in Lodi, California, in 1980.

Bambolo's brother-in-law, Calcedonio Ferraro, registered for the military draft in 1918 after being charged with cracking a safe at the Acme store on North Hill. Following the war, he was convicted of burglary and grand larceny. Upon parole from prison, he settled in Chautauqua, New York, where he lived with his wife, worked as a finisher in a furniture factory and maintained a low profile, dying in January 1967 at age eighty-six.

Filomena Borgia disappeared from the public eye after the execution of her husband, Rosario Borgia. After being shut out of the gangster's will, reportedly worth $10,000 (about $191,000 in 2017), she quietly walked away. Official documents shed little light on her departure from Akron. Someone with her name died in 1923 in New York, but that might be a coincidence. Perhaps she remarried using one of her husband's many aliases. If so, one can only hope that she became more selective in her choice of men. But wait a minute. Census records from 1930 show a Filomena Borgia living in

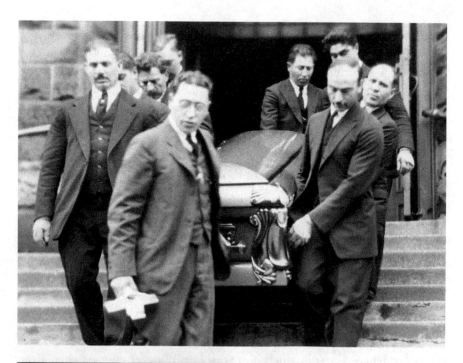

Above: Pallbearers carry the casket of Frank Bellini following his funeral in 1929. The Akron gangster was gunned down outside his store on North Howard Street. *From the* Akron Beacon Journal.

Left: The Furnace Street Mission, the "Brightest Spot in the Underworld," opened in the late 1920s in Joe Congena's old pool hall. Rosario Borgia plotted the murder of Akron police officers at the hangout in 1917. *Author's collection.*

New York with a Dominick Borgia. Rosario's beneficiary was his brother Dominick. You don't suppose...could it be?

Private investigator George Martino closed his detective agency in 1919 and got caught in a 1922 liquor-smuggling racket using the Lynn Drug Company as a front. Federal agents seized 139 cases of liquor in the showroom of the East Market Street business near Union Depot. In 1923, he was sentenced to eighteen months in the federal penitentiary in Atlanta for conspiracy to defraud the government in violation of the Prohibition law. His name disappeared from Akron newspapers.

Michael Fiaschetti, the New York detective, received two gold medals in September 1919 from Mayor I.S. Myers and the Akron Chamber of Commerce "for exceptionally skillful work" in helping to solve the police slayings. The Italian Squad director drew the ire of Akron police, however, when he wrote a 1929 article for *Liberty* magazine in which he took most of the credit for cracking the case. Officers objected, saying Fiaschetti mostly served as an interpreter in 1918. "If Fiaschetti's other stories are as authentic as this one about the Borgia gang, I pity the poor readers," Detective Edward J. McDonnell noted. Fiaschetti penned a few autobiographies and retired from the force to become a private detective. He died at age seventy-eight on July 29, 1960, at a VA hospital in Brooklyn.

Patrolman Walter Horn was seriously injured in July 1919 when his motorcycle crashed into an automobile. He was allowed to resign from the force in November 1920 after he was charged with conduct unbecoming an officer and neglect of duty. He died on November 23, 1964, in Detroit, where he had moved in 1940 to work for the Ford Motor Company.

Detective Harry Welch was named the chief of the detective bureau when it was organized in 1921. He retired from the force on January 1, 1928, after thirty-one years in the department and ran a private detective agency for a few years. "Other good men may come and may fill Welch's job very efficiently, but for the old-timers, the gap in the roster made by Welch's resignation will never be made up," Captain Frank McGuire said. Welch suffered a heart attack on January 17, 1933, while driving his car on Glendale Avenue and died en route to a hospital. He was sixty-two years old.

Detective Bert Eckerman, who joined the force in 1903, retired in 1932 after twenty-nine years on the job. At his testimonial dinner, Eckerman told the audience, "Of course I thank you and there isn't much else to say, but maybe you'll remember this, or maybe some of the newer police officers here and others who are to come, will remember: I wouldn't lie on a man. I

wouldn't send a man to the penitentiary unless I knew he was guilty…and there was never a man come out of that penitentiary, if I sent him there, who wasn't willing to shake hands with me." The 280-pound detective died of pleurisy in 1943 at age seventy-five.

Edward J. McDonnell was named chief of the detective bureau in 1928 after Welch retired and was promoted to captain in 1930. In celebration of McDonnell's twenty-fifth anniversary with the force, more than five hundred people attended a testimonial dinner in his honor on February 1, 1933, at the Mayflower Hotel. "What success I have had, if I've had any, I owe to the men in the detective department and to the good citizens of Akron," he told the crowd. "From the bottom of my heart, I want to thank each and every one here for making this one of the most important events of my life." McDonnell had an appendix operation in May 1933 and died unexpectedly a week later of a blood clot to the heart. He was only forty-nine. "The days of a good life are numbered, but a good name continues forever," Reverend James H. Downie eulogized at St. Vincent.

John Durkin was one of only six patrolmen when he became a cop in 1883. "When I joined the force, there wasn't a streetcar in Akron," he recalled. "There were no electric lights and Market Street was the only thoroughfare in town which boasted paving." He remained on the job for forty-seven years—a department record—and served as chief for thirty years until failing health forced him to retire on February 1, 1930. Colleagues hailed him for revolutionizing the department. Durkin was seventy-nine when he died on April 14, 1939. "As chief of police, Durkin adhered to a simple code," the *Beacon Journal* noted. "On matters which he considered of secondary importance, he gave the town as much or as little law enforcement as it wanted, but he insisted upon the fundamental virtues of honesty and bravery at all times. The results of this course were unquestioning loyalty from his men and the respect of the people."

Detective Pasquale "Patsy" Pappano spent twenty-seven years with the department, retiring in 1944. "I've had my fill of pounding pavements and chasing criminals," he explained. "I feel I've earned a good, long rest—and I intend to take one." The Italian American cop was sixty-seven when he died after a short illness on January 31, 1960. "Patsy's unique qualifications and reputation often induced police of other cities to ask for a loan of his services on tough cases," reporter Kenneth Nichols recalled. "The hard shell he showed toward the lawless was just that—a shell. He was a kindly, good-natured man, a trencherman who could make a plate of Italian food vanish as a magician does a rabbit."

During his first decade on the force, Stephen McGowan was shot three times and dodged at least another dozen bullets. In 1929, he helped capture gangster Pretty Boy Floyd, who was hiding under a bed at a Lodi Street home. He was promoted to lieutenant in 1930 and captain in 1942. McGowan loved being a policeman and refused to retire. "What would I do?" he said. "Sit in a rocking chair on my front porch? Everything that is dear to me is here in Akron and at the police station." He had nearly forty-five years of service when he died of a heart attack behind the wheel of his cruiser on February 23, 1963. He was seventy-nine.

Unlike McGowan, Detective Will McDonnell had no qualms about dying on his front porch. After nineteen years of service, the detective retired on pension in May 1932, still carrying two slugs in his body from the 1919 shootout. "I've had enough excitement to last me a long time," he once told a reporter. McDonnell died of a heart attack on August 30, 1953, on a porch swing at his Gale Street home. He was seventy-two.

Louis Hunt turned five years old the day his father, Joseph Hunt, a rookie officer, died on January 12, 1918. "I'll grow up and I'll be a cop—a good cop like my daddy," the little boy vowed during the funeral. In 1938, Louis took the civil service exam and joined the force a year later at age twenty-seven. "My father never had a chance," he explained. "I want to take up where he left off." Somewhat surprisingly, his widowed mother, Adale, was in favor of the move. "It's a dangerous life, but a good policeman is a fine citizen," she told a reporter. The younger Hunt served thirty-three years on the force, working in the traffic division, vice squad, patrol division and communications before retiring as a sergeant in January 1974. "I've enjoyed working as a policeman," Hunt said. He was seventy-eight when he died on May 25, 1991.

Judge Ervin D. Fritch retired in February 1943 after more than twenty-eight years on the Summit County Common Pleas bench. More than four hundred attended an Akron Bar Association banquet honoring him as "the best trial judge the county ever had." In 1957, Fritch created a fund at the University of Akron that awards annual scholarships to students based on academics, financial need, moral character and ability. "No judge in our history has exceeded Judge Fritch in judicial interest, judicial temperament, judicial ability and the courage to meet the issues of the day," retired Firestone executive Joseph Thomas noted in October 1963 during Fritch's ninetieth birthday celebration. Fritch, a small man with a big brain, died on March 24, 1969, at age ninety-five.

Judge William J. Ahern Jr., who presided over the Peter Cafarelli and Vincenzo Damico cases, served a decade on the Summit County Common

Pleas bench before stepping down in May 1923. He was only thirty-eight years old when he died unexpectedly on July 21, 1924, of heart failure after a lengthy battle with pneumonia. Judge Lionel S. Pardee, who succeeded Ahern, cried when he heard the news. "It is too bad that a young man with such a brilliant future had to die," Pardee said. "Judge Ahern will be missed very much. He was a good friend of mine, and I always found him honest, courageous and a worker."

Cletus G. Roetzel served two terms as Summit County prosecutor before resuming his law practice in Akron. In 1949, Pope Pius XII named Roetzel a Knight of the Order of St. Gregory the Great. He was the senior partner at Roetzel and Andress, a law firm that bears his name, when he died on October 15, 1973, at age eighty-four. He had served in leadership positions at the Akron Art Institute, Akron Bar Association, Catholic Service League, St. Thomas Hospital and the University of Akron. "The life he helped breathe into these institutions is his proud and continuing legacy to Akron," the *Beacon Journal* eulogized.

Former prosecutor and assistant prosecutor Charles P. Kennedy, who helped Roetzel convict the Furnace Street gang, formed the Ormsby & Kennedy law firm and was elected president of the Akron Bar Association in 1928. The group saluted him in 1960 for serving fifty-four years as an attorney. He died on March 26, 1965, at age eighty-one in his home in Sarasota, Florida.

Rosario Borgia's defense attorney, Abram E. Bernsteen, enjoyed many victories after that infamous loss. President Warren G. Harding nominated him in 1923 as U.S. attorney for the northern district of Ohio, and he served until 1929. Bernsteen finally moved out of his parents' home and married his assistant, Irene Nungesser. He gave serious consideration to running for governor in 1928 but thought better of it. Bernsteen died on April 5, 1957, of a heart attack at the Cleveland Clinic. He was eighty.

Barberton attorney Stephen C. Miller, who assisted Bernsteen with the Borgia case, barely outlasted the Furnace Street gang. Regarded as a brilliant legal mind, Miller practiced law for more than three decades before dying of diabetes on October 9, 1923, at age sixty.

Attorney Seney A. Decker did not pay a political price for mishandling the stay of execution for Pasquale Biondo in 1918. The following year, he was elected Barberton mayor and served two terms. He also was the first president of Barberton Kiwanis and Barberton Eagles. Decker was found dead in his bed of an apparent heart attack at age sixty-one on December 30, 1936.

Frank Mazzano's defense attorney Orlando Wilcox served as Cuyahoga Falls city solicitor and director of Cuyahoga Falls Savings Bank and the Falls Savings & Loan Association. He died on January 17, 1932, at age eighty after suffering a stroke. "He was thorough as an advocate, wise as a counselor, always respected as an antagonist, and not infrequently to be feared," attorneys C.T. Grant, W.E. Slabaugh and Harvey Musser noted in a prepared statement mourning the loss of their colleague.

Amos H. "Tiny" Englebeck, Wilcox's assistant in the Mazzano case, went on to serve as chairman of the Republican Executive Committee and president of the Summit County Board of Health. He was monarch of Yusef-Khan Grotto, potentate of Tadmor Temple, sovereign grand inspector general of Ohio and grand high priest of the Royal Arch Masons. After he died on September 11, 1952, at age sixty-six, local Masons honored his memory by naming the Amos H. Englebeck Lodge after him.

Reverend Francis Louis Kelly, Ohio Penitentiary chaplain for more than twenty-five years, retired in 1927 and died on February 10, 1932, at age eighty at the Dominican Fathers' Home for the Aged in Minneapolis.

Cleveland attorney Benjamin D. Nicola, legal counsel for Lorenzo Biondo, practiced law for sixty years. He was named U.S. commissioner in 1930, appointed Cuyahoga County Common Pleas judge in 1948 and retired in 1964 at age eighty-five. He died on March 21, 1970, at age ninety-one in Aurora in Portage County.

Convicted murderer Lorenzo Biondo, alias James Palmieri, was sentenced to life in prison for the 1918 slayings of Joe Hunt and Edward Costigan, but it didn't work out that way. In a shocking turn of events, Governor George White commuted the sentence on May 25, 1934, for reasons that remain mysterious. Biondo, age thirty-five, was freed from the Ohio Penitentiary, placed on the Italian ocean liner SS *Rex* in New York and ordered never to return to the United States. Former judge Ervin D. Fritch and former prosecutor Cletus G. Roetzel weren't informed of the parole and didn't find out for several years. "The police department would certainly have left no stone unturned to keep Biondo in prison if it had had any knowledge of the parole move," Detective Inspector Verne Cross fumed in 1938. A free man, Biondo returned to his native land just before World War II engulfed Europe. His final fate remains unknown to this day.

Anthony Manfriedo wasn't as lucky. Sentenced to life in prison at age twenty-one for being the lookout when Costigan and Hunt were slain, Manfriedo was locked up and forgotten for nearly fifty years. *Beacon Journal* reporter Carl J. Peterson found him in 1965 at the London Correctional

Institution. Manfriedo, age seventy, a prison nurse for two decades, had just requested parole for the fifth time. "I'm not getting any younger and I don't want to die in prison," he told the reporter. "I want to enjoy a freedom that I have had so little of in my lifetime." Manfriedo was apologetic for his role in the killings. "It was my own fault," he explained. "I was a young kid. Just got here in this country and didn't think. I'm not mad at anybody now. I don't think I have an enemy in the world."

On November 22, 1965, Governor James Rhodes pardoned Manfriedo and expunged his criminal record. "I never thought this day would come," Manfriedo said. "I hope all the time. I never give up hope." Roetzel, the former prosecutor, and Fritch, the former judge, had recommended

Former Akron gangster Tony Manfriedo is happy to be a free man after receiving a state pardon in 1965 following nearly fifty years in prison. *From the* Akron Beacon Journal.

parole as early as 1950, to no avail. "I think it's a good idea," Roetzel said. "Actually, it should have been done earlier. I'm a very firm believer in comparative justice. It's disturbing to me when one man gets a severe penalty and another, under similar circumstances, gets a lighter penalty." Judge Fritch added, "I feel Manfriedo deserved to be freed. He's the last of the Borgia gang left. I think he was in prison too long as it is."

A gray-haired, bespectacled Manfriedo returned to Akron for a visit on Tuesday, November 30, and was amazed with what he saw. "This not the same city," the Sicilian native told reporter Carl J. Peterson in broken English. "I never believe Akron look like this!" One of the few places that looked familiar was the Goodrich plant, where he worked in 1917 before falling in with the wrong crowd. "I don't know anyone here anymore," Manfriedo shrugged. "It's been too long."

Manfriedo returned to Columbus and found a job at a nursing home. His left eye had to be surgically removed in 1967 because of a tumor, but in his last known interview at seventy-two, he told a reporter, "I would rather be a free man with one eye—and enjoy this good fresh air—than be in the prison with both eyes."

Appendix

NEVER FORGET

Over the past century, the list has grown. Twenty more names have joined the Akron honor roll since police officers Guy Norris, Edward J. Costigan, Joseph H. Hunt, Gethin H. Richards and George Werne were murdered from 1917 to 1919 in the performance of their duties.

Shootings, car crashes, fatal heart attacks and a drowning have claimed the lives of Akron officers as they worked to protect and serve their community. They were husbands, fathers, brothers, sons, nephews, boyfriends, neighbors, buddies—a solid line of blue that stretches out to infinity. Their sacrifices will be remembered long after they are gone.

In 1961, U.S. Representative George P. Miller, a Democrat from California, and U.S. Senator J. Glenn Beall, a Republican from Maryland, co-sponsored a joint resolution to designate May 15 as Peace Officers Memorial Day. The week on which the date occurs was christened "Police Week." "The many thousands of American men and women engaged in the profession of law enforcement have too long been without proper recognition for their efforts," Miller announced. "This law will provide an opportunity for focusing national attention upon the accomplishments of this vitally important group of professional people who have dedicated their lives to preserving the property and safety of the American people."

President John F. Kennedy signed the proclamation on April 10, 1962, "in recognition of the contributions the police officers of America have made to our civilization through their dedicated and selfless efforts in enforcing our laws." Kennedy called on the American public and all patriotic, civic

and educational organizations to observe Police Week "with appropriate ceremonies in which all of our people may join in commemorating police officers, past and present, who by their faithful and loyal devotion to their responsibilities have rendered a dedicated service to their communities and, in so doing, have established for themselves an enviable and enduring reputation for preserving the rights and security of all citizens."

The commemoration began small in Akron. The police department put up a photo display of the fallen officers, who then numbered twelve, in a large window at O'Neil's department store in downtown Akron. Officers wore white shirts with black bands on their badges in memory of their brethren. Fraternal Order of Police Lodge 7 laid a wreath on a plaque in the lobby of the police station. The lodge concluded the week with a covered dish dinner at Carter Park in Tallmadge.

Year by year, the commemoration grew. It became more of a public wake than a private grieving. Survivors and descendants of the late officers were invited to attend the services and speak about their loved ones. Crowds have gathered every year since. "The reason we hold this every year is to give a solemn reminder to the public that the men are out every day of the year and hour of the day protecting them and putting their lives on the line," Chief Harry Whiddon said in 1968.

A twelve-ton granite marker became a focal point of the annual event in 1997 after the FOP raised $50,000 to place a monument in front of the Harold J. Stubbs Justice Center on South High Street in downtown Akron. The justice center was built on the site of the old Summit County Jail, where the Furnace Street gang spent many an uncomfortable night.

More than one thousand people attended the dedication ceremony on May 13, 1997, where a black tablet was unveiled with the etched names of Akron's fallen officers. The honor roll, adjacent to a granite FOP star, rests on a gray granite base measuring twelve feet wide and ten inches thick. "We can only hope and pray that no more names will be added to this honor roll on the tablet," Mayor Don Plusquellic told the assembly.

But something seemed missing. Chief Michael T. Matulavich proposed adding an eternal flame to the monument in July 2001 after seeing one at a police memorial service in Ottawa, Canada. The Fraternal Order of Police embraced the idea and raised $25,000 for the addition. Nearly 2,000 people, including 750 motorcyclists, attended the lighting ceremony on July 14, 2002.

Retired Akron officer Jonathan "Russ" Long, who was paralyzed following a 1991 crash in a high-speed chase on Hazel Street, delivered an Olympic

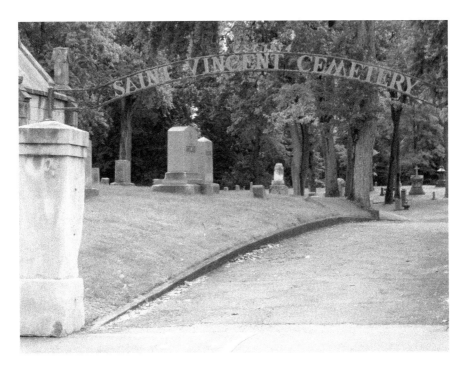

Patrolman Ed Costigan is buried next to his mother at St. Vincent Cemetery in Akron. Their graves no longer appear to be marked in the heavily vandalized cemetery. *Photo by Mark J. Price.*

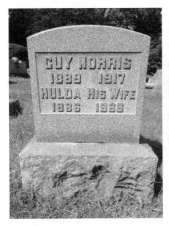 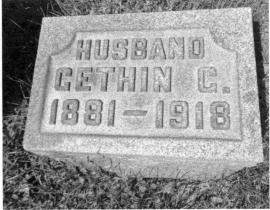

Left: Patrolman Guy Norris is buried with his wife, Hulda, at Mount Peace Cemetery in Akron. No one was ever charged in his killing. *Photo by Mark J. Price.*

Right: Patrolman Gethin Richards is buried with his wife, Frieda, at Mount Peace Cemetery in Akron. *Photo by Mark J. Price.*

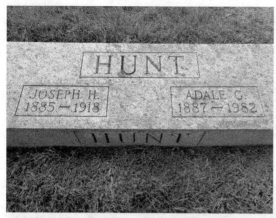

Left: Patrolman Joseph Hunt is buried with his wife, Adale, at Holy Cross Cemetery in Akron. *Photo by Mark J. Price.*

Below: Patrolman George Werne is buried with his wife, Anna, at Holy Cross Cemetery in Akron. *Photo by Mark J. Price.*

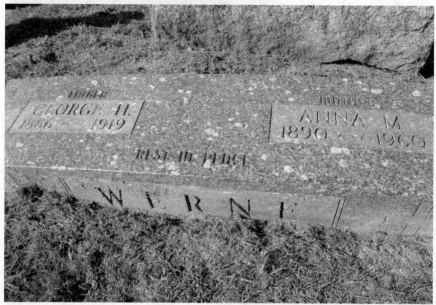

torch in his wheelchair to JaRae Shaw, age twenty-four, the daughter of officer Ben J. Franklin, who suffered a fatal heart attack on January 10, 1992, while breaking up a fight and making an arrest. She lifted the torch and lit the eternal flame in front of a large granite plaque that read, "NEVER FORGET." "It means the world to me to be able to pay tribute to my father and the other officers who gave their lives," she told the *Akron Beacon Journal*.

Addressing the crowd, Chief Matulavich noted, "This eternal flame is not Akron's flame. It is to honor every law enforcement officer who has lost his life across this country."

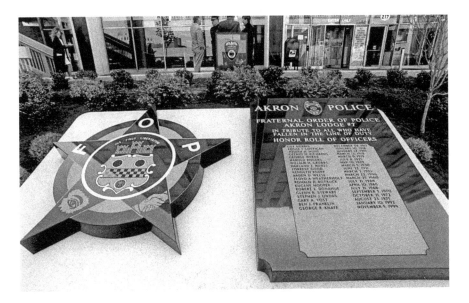

The Akron police memorial is dedicated in May 1997 in front of the Harold J. Stubbs Justice Center in downtown Akron. Sadly, the honor roll has grown longer since the dedication. *From the* Akron Beacon Journal.

Paul Hlynsky, president of Fraternal Order of Police Lodge 7, explained, "This project represents a bond between the police department and the community. It reflects that we all care, we all stick together, and we all want to make sure these officers are always remembered for the sacrifices that they made."

The torch has been glowing ever since. It costs more than $2,500 a year to maintain the eternal flame, which is powered by natural gas. It flickers night and day, sunshine and rain, catching the attention of motorists and pedestrians along South High Street.

Sadly, Russ Long's name was engraved on the monument after he died at age fifty-one on August 15, 2013, from complications from the injuries in his 1991 crash. Officer Justin R. Winebrenner, age thirty-two, joined the honor roll after he was shot to death on November 16, 2014, during a struggle with an armed man at an East Market Street pub. The community can only hope and pray that he will be the last.

The Akron Police Museum, which opened in the late 1960s, offers a repository of crime fighting memorabilia on the mezzanine level of the Harold K. Stubbs Justice Center at 217 South High Street. Among its exhibits are vintage photographs, news clippings, police uniforms, badges,

Standing inside the Akron Police Museum in 2017, Detective Jim Conley holds the revolver that Frank Mazzano used to kill Patrolman Gethin Richards in 1918. *Photo by Mark J. Price.*

patches, nightsticks, lie detectors, gambling machines, a 1965 Harley-Davidson motorcycle and the original 1916 headstone of Chief Hughlin H. Harrison. A glass case contains a shelf crowded with an assortment of confiscated weapons, including the revolver that Frank Mazzano used to shoot Patrolman Gethin Richards.

In tribute to all Akron police who have fallen in the line of duty:

1917: Guy Norris
1918: Edward J. Costigan
1918: Joseph H. Hunt
1918: Gethin H. Richards
1919: George Werne
1925: Harold Rogers
1929: William H. Grubbs
1930: Harland F. Manes
1931: Forrest Good
1933: Kenneth Knepp
1933: William S. Peterson
1946: Arden D. Weese
1960: Floyd A. Weatherholt Jr.
1964: Ronald D. Rotruck
1965: Eugene Hooper
1968: Robert E. Donahue
1970: Glenn K. Stewart
1972: Stephen J. Ondas
1975: Gary A. Yost
1992: Ben J. Franklin
1993: Harold L. Wintrow
1994: George R. Knaff
2012: Frank D. Mancini
2013: Jonathan R. Long
2014: Justin R. Winebrenner

Never forget. May there never be another name added to the list.

SOURCES

Books

Avery, Elroy McKendree. *A History of Cleveland and Its Environs*. Chicago: Lewis Publishing Company, 1918.

Buie, Lieutenant James C., and Captain John T. Cunningham. *History of the Akron, Ohio, Police Department, 1898–1995*. Akron, OH: Akron Police Department, 2003.

Burch Directory Company. *Akron City Directory*. Akron, OH: Commercial Printing Company, various years.

Doyle, William B. *Centennial History of Summit County, Ohio, and Representative Citizens*. Chicago: Biographical Publishing Company, 1908.

Fiaschetti, Michael. *You Gotta Be Rough*. Garden City, NY: Crime Club Inc., 1930.

Grismer, Karl H. *Akron and Summit County*. Akron, OH: Summit County Historical Society, 1952.

Howe, Henry. *Historical Collections of Ohio: An Encyclopedia of the State*. Columbus, OH: Henry Howe & Son, 1891.

Knepper, George W. *Akron: City at the Summit*. Akron, OH: Summit County Historical Society, 1981.

Lane, Samuel Alonson. *Fifty Years and Over of Akron and Summit County*. Akron, OH: Beacon Job Department, 1887.

Love, Steve, and David Giffels. *Wheels of Fortune: The Story of Rubber in Akron*. Akron, OH: University of Akron Press, 1998.

Olin, Oscar Eugene. *Akron and Environs: Historical, Biographical, Genealogical.* Chicago: Lewis Publishing Company, 1917.

Olin, Oscar Eugene, and A.E. Allen. *A Centennial History of Akron, 1825–1925.* Akron, OH: Summit County Historical Society, 1925.

Perrin, William Henry. *History of Summit County: With an Outline Sketch of Ohio.* Chicago: Baskin & Battey, 1881.

Veronesi, Gene P. *Italian Americans and Their Communities of Cleveland.* Cleveland, OH: Cleveland State University Press, 1971.

Periodicals

Akron Beacon Journal.
Akron Evening Times.
Akron Press.
Akron Times Democrat.
Akron Times-Press.
Canton Daily News.
Cleveland Plain Dealer.
India Rubber World.
Journal of the Cleveland Bar Association.
Liberty Magazine.
Mansfield News.
Massillon Evening Independent.
McClure's Magazine.
National Police Journal.
The Outlook.
10 True Crime Cases.

Useful Websites

Akronlibrary.org.
Akronohio.gov.
Books.google.com.
Familysearch.org.
Findagrave.com.
Heritagepursuit.com.
News.google.com/newspapers.

Newspaperarchive.com.
Newspapers.com.
ODMP.org.
Ohio.com.
Ohiohistorycentral.org.
Ohiohistory.org.

INDEX

ABOUT THE AUTHOR

Mark J. Price is an award-winning journalist from Akron, Ohio. A 1981 graduate of Akron North High School, he earned his journalism degree from Kent State University in 1985. He has worked as a copy editor and staff writer for the *Akron Beacon Journal* since 1997. Before that, he worked as a copy editor, columnist and features editor at the Canton Repository. He is the author of *The Rest Is History: True Tales from Akron's Vibrant Past* (University of Akron Press, 2012) and *Lost Akron* (The History Press, 2015). He and his wife, Susan, live in Hinckley, Ohio, with their puppy girl, Cinders, and bunny girl, Katie.

CPSIA information can be obtained
at www.ICGtesting.com
Printed in the USA
LVHW082110210123
737693LV00002B/8